BECOMING WHOLE AGAIN
A healing legacy for our daughters

First published by Busybird Publishing 2024

Copyright © 2024 Shannon Rose

ISBN:
Print: 978-1-923216-31-0

This work is copyright. Apart from any use permitted under the *Copyright Act 1968*, no part of this publication may be reproduced, stored in a retrieval system or transmitted in any form or by any means, electronic, mechanical, photocopying, recording or otherwise, without the prior written permission of Shannon Rose.

The information in this book is based on the author's experiences and opinions. The author and publisher disclaim responsibility for any adverse consequences, which may result from use of the information contained herein. Permission to use any external content has been sought by the author. Any breaches will be rectified in further editions of the book.

Cover Image: Sarah Maqboab

Cover design: Sofia Darling

Layout and typesetting: Busybird Publishing

Illustrations: Sarah Maqboab

Busybird Publishing
2/118 Para Road
Montmorency, Victoria
Australia 3094
www.busybird.com.au

It is in your unbecoming and the gentle unraveling of all that was never yours to begin with, that the journey to Becoming Whole Again begins.

Walk inside, let's take the first step.

To the women who walked before us, to the women who walk beside us and our daughters, whether by blood or soul family, who walk behind us.

Foreword

When I was asked to read this book & write the Foreword for it, it didn't matter how busy I was (as a Mom, business owner, and globally ranked podcast host I tend to have very full days). This was an invitation that I felt deeply compelled to find the time for as it is a conversation that hits home to the very core of my personal purpose in life & business.

Sharing Our Stories - the pain, the rock bottoms, the moments where we did not think we could go on, and then what it took to heal, to choose life, to become new, to find God, and thrive; and then carry that message of hope to someone else - has the potential to truly heal the world.

As a Recovering Alcoholic, we often talk about sharing our 'experience, strength and hope';

we share 'what it was like' (the pain, the rock bottom, the total dysfunction), 'what we did' (how we healed, the work we put in), and 'what it's like now' (the miracles of recovery, what our lives look like as a result of choosing God and self) - this depth of vulnerable and honest storytelling is something sacred, and so rare to find outside of the rooms of recovery.

And so, a book like Becoming Whole Again - A Healing Legacy For Our Daughters is not just important, it's the key to walking a path of healing and hope together while changing the fabric of reality for our children; may they never know the pain we have, that they may always know that healing is available and hope is never lost.

In the Letter To The Reader, there is a line that says "Once we make a decision to move toward our unbecoming, the hands of the divine will begin to turn in our favor", and this has been my personal experience and the experience I have seen working with hundreds of women. Once we 'let go and let God' by dropping all of the ways we thought it was supposed to be, all of our control, all of our pain & resentments (which usually happens as a result of hitting some kind of a rock bottom on our personal journey, and finding the Gift Of Desperation), God finally has a chance to come in and guide us, re-mould us, make us whole, and position us for His mission through us.

Becoming Whole Again - A Healing Legacy For Our Daughters is a tapestry of women's stories all of which guide us back home to the space of 'unbecoming' so that we may 'become' once again. I believe that every single reader who holds this book in her hands will be able to relate to some of every single story told by the women who Authored this book, which means that every single woman who reads the words on these pages will walk away a little more hopeful, a little more seen, a little more… whole!

And it is here that these women's stories, vulnerability, and truth get to morph the fabric of our knowingness - collectively - moving forward.

What a gift.

To see God work through women in this way, to know that He uses our Mess as His Message is so deeply comforting because it shows us two things:

What we go through is never in vain.

This does not mean that 'everything happens for a reason', but rather, it means that what we go through - no matter how dysregulating, shame-filled, traumatic, or painful - will be used in service of someone else. God heals us from our darkness so that we may become lighthouses for others. The women in Becoming Whole Again - A Healing Legacy For Our Daughters are the Lighthouses that this world needs.

I pray every reader finds her light through these stories.

We are not alone.

There is simply nothing more healing than knowing that voice of shame that tells us we are solo, alone, doomed to a path of never belonging … is a lie. When we hear a story and we can identify with either the story itself, or the feelings that someone else feels, and we can feel the "me too" feeling in our core, and we know that We Are Not Alone, we begin to heal on a cellular level. Shame can not co-exist in the light of women holding hands and walking shoulder to shoulder sharing our experience, strength, and hope.

Becoming Whole Again - A Healing Legacy For Our Daughters is a must-read for every woman.

My prayer for the reader is that we each find what we didn't even know we were looking for living in the words on these pages. May we begin to crack open in the sacred journey of unbecoming - knowing that we are not walking this path alone, knowing that other women have been here too - and may begin to become what God has us here to become.

To the women who ushered this book to those of us blessed enough to receive it, Thank You.

Your stories are healing us all.

With Love,

Kori Leigh

Welcome Prayer

Before turning the pages of this book and diving into what awaits, I invite you to bring your hands to heart and take three full breaths. As your inhale brings rise to your chest—feel it fully. Now, as the exhale falls, allow your entire body to relax, to be completely here, in this moment.

Continue to breathe consciously and intentionally, now leave one hand on your heart and bring the other palm up to receive as we share this prayer:

God/Spirit, I pray for your love and light to continuously guide me.

May my healing journey be one that is free from judgment, limitation, and expectation.

May I be clearly guided to the work that is mine to responsibly hold and heal, and liberated from all that is not mine to tend to.

God/Spirit, I pray that when doubt enters the room and my old ways creep back in, that you open my eyes and have me see.

I pray that you encourage me to take a breath and pause, so I may learn how to intentionally and kindly respond rather than react and act from my projections.

May my journey be one where duality reigns while gently bringing me into the fullest expression of what it means to be a human walking on this great earth.

I am open, God/Spirit to feel it all, because I am available to heal it all.

May I learn and know the ways of nature and the people who walked before me.

Welcome Prayer

May you help me to remove my ego on the days where distraction and disconnection steals my focus. I ask that you steer me back to the sacred ways that have always moved within me.

God/Spirit, thank you for walking by my side, for being the wind at my back and the sun on my face, especially on the days that feel a little darker.

God/Spirit please show me where I hold myself back so that I can be a great steward of love, of light, and of healing.

Thank you, thank you, thank you.

Amen. Amen. Amen.

Letter to the Reader

Dear Beautiful Soul,

It is in full body gratitude that I write this to you. Thank you for acknowledging the whispers that called you to pick up this book and join us in what it means to be "Becoming Whole Again."

For you, it will likely mean something very different to what it means to me, and so it should, because you and I, while divinely created and connected, are unique beings—as unique as our fingerprints.

As you move from page to page, do so with love, compassion, and complete trust in yourself to soak in what is here for you—without judgment, criticism, or comparison. Allow this book to become a playground where you remove these characteristics from your body. If this feels hard for you, go forward gently. It will be a work in progress—it still is for me, and that is more than ok.

We have each grown up in a world that is deeply conditioned. A lot of what we think and feel, and how we relate to the world—even the tone, pitch and pace of our voice—has been impacted and influenced by what has been passed down to us; by what we see on TV, read in books, learn in schools, or constantly have marketed to us.

Removing the veil of conditioning takes time. Healing takes time. Once we make the decision to move toward our unbecoming, the hands of the divine will begin to turn in our favor:

"Are the hands of time spinning in uncertainty or being turned by the divine?"

- unknown

Woven into every page you turn, are moments where we have each tripped and fallen, where we have been swallowed by uncertainty, by fear, by our pain and the shame that has lived within our bodies.

Healing happens when we release the grip of trying to make sense of every moment from our past, present and future, to instead come home to embodying the reality that we are already whole.

We always have been.

And as every step into the unknown was required to get you to where you are today, every continued step into the unknown is required in order to remember.

I want you to know that there is courage woven into every page of this book.

Our story is our offering. Your story is your offering. That offering brings medicine for another woman. The wisdom for you here, is revealing where you are holding back on the story that lives within you.

In order for our words to land on these pages, bravery, careful intention, and deep levels of intimacy within ourselves and our stories, had to be cultivated and met.

I want you to know that this book is not just about reading other people's stories. It is about seeing yourself in parts of someone else's story, and for that to call you forward into your personal growth through greater levels of awareness.

The women who picked up their pens to begin writing this book are not the same women who stand by my side today. Their voice and posture have transformed. When I look into their eyes, hear them speak, and feel their energy, I am reminded of the power that lives within the sharing of our stories. It is only in the telling of these, that the medicine is released and healing is anchored.

Today, because of this journey, I have a better articulation of Self; the Self who has always been there behind the masks, behind the conditioning and the shame. While I have known for some time that sharing my story could provide me with healing, the lump in the back of my throat remained.

Nothing quite compares to writing an entire book with the power to birth a movement, and live on the coffee tables of our daughters and granddaughters for generations to come. What I now know to be true is that when the vision is deeply anchored, when it aches within you to be freed, it obliterates the doubt and compels you to move.

May this book be a mirror for you.

May this book show you that our internal conversations between us and ourselves need to change in order to heal our families, our communities, and humanity as a whole.

May this book offer you sanctuary in the times where you struggle to make peace with your past or the times where you feel isolated on your healing journey.
May this book support you in healing the shame that has lived within your body for too long.

The process of writing this book has offered deep healing, far beyond what I had expected. The point I want to make here is that when we leave expectations at the door, we are delivered far beyond anything we could ever imagine.

We open ourselves up.

And while that too can feel scary, it is one of the most liberating things we can do.

May this book be the invitation you have been waiting for to tear down the walls and lean hard into sacred ways that live within your DNA.

Writing Becoming Whole Again has completely transformed each one of us, and I will be forever changed because of it.

May this book be the first sentence written in a brand new conversation of what it means to live, love, and lead dripping in wholeness, as a woman and as sacred daughters of this great land.

Walk whole,

Shannon

How to use this book

Becoming Whole Again is uniquely created to take you on a journey alongside every story of healing held within its pages.

As you delve in and explore what lives within the chapters and exercises that call to you, know that this book does not need to be read in any specific order; rather, you are encouraged to turn the page and begin wherever you are being guided.

At the end of every chapter you will be invited into opportunities of self reflection, moments of pause and meditation, explorations of your inner landscape through journaling, spiritual and life "ah-ha" moments coupled with the offering of divine guidance and artistic expression.

It is encouraged that you move through each chapter and its exercises as a whole experience: if you begin with Chapter Five, complete it in wholeness by completing the offering at the end from the Author. After all, that is what this book and movement is all about!

Please be aware that Becoming Whole Again comes with a trigger warning.

Within this book there are stories that mention miscarriage, emotional and physical abuse, sexual assault, body dysmorphia, eating disorders, surgery, and other traumatic events. While every care has been taken to cushion some of our more triggering chapters between those that are more nurturing and softer, when moving through this book, please move gently.

We encourage you to honor your body with every page turned.
We encourage you to listen to her, and if she feels activated, pause.
We encourage you to, always and every day, spend time in nature, unplug from your devices and allow yourself to be present when soaking in the wisdom that permeates through all that we do, all that we are, and all that we give and receive.

While we are healed, we are still healing and embrace our imperfections as being perfectly and divinely human and whole.

Pour that cacao or cup of tea, sit back and get comfy,

It is time ♡

The quieter you become, the more you are able to hear
RUMI

CHAPTER ONE

Love Hurts. A Pilgrimage Of Coming Home
Body Wisdom. Loving Self. Remembering Sacred Ways.

The Remembering

The earth shook as I howled at the moon, my legs sturdy beneath me, my heart as wide as my cervix. We later learned that primal, deep guttural howl was heard by our neighbors almost a kilometer away. My daughter was close, almost too close, to brave the drive to the birthing center.

Barely able to walk, even with the strength of my man holding me, I edged toward the car just as another surge came closer and my baby's head fell deeper, setting spark to the ring of fire. There was no pain—the adrenaline coursing through my veins was doing its job. My entire being was completely immersed in the task of guiding me through the portal of birthing life into the world.

No one can prepare you for what it means to become a Mother. Whether your child arrives through the portal God designed or they arrive through "the sunroof," it is one hell of a ride.

This was the first time I knew what it meant to trust my body, to give up my will, and to hand it all over to a power greater than myself. I am not an elder, I wouldn't say that I am even old. I have not lived more than three full decades walking this earth, but I have learned.

I have learned what it means to live under the illusion that we are just a body. Where every day is void of what I sought the most, where presence and the ability to be with oneself is near impossible, distracted and consumed by thoughts that are not truly our own. Where emptiness and surface level living reigned. Those lessons cost me greatly; they cost me friendships, they cost me my time, energy, heartache and money, but above all, they cost me the most beautiful relationship in the world, the one that existed between me and myself as a young woman.

That power was restored, however, when I entered the birth portal, a rekindling of what would become the most intimate love of them all.

This is my story of coming home.

Nature's Rhythm

High in the Austrian Alps, my son collects mud from beneath the stones in the crystal clear alpine river. My skin still cold from bathing in the near-freezing water, I watch my daughter create an artwork of mud and little stones on a larger rock next to me. Then, my gaze catches on my husband. His presence with my son feels like the presence of the mountains surrounding us. Grounded, powerful, loving, guiding, true.

I had always dreamed of having a family, of being loved the way I am here, of being held so sturdy when he wraps his arms around me, and for me to simply be me. All of me. As strong as I am soft, as fierce as I am feminine, as stable as I am reactive, as much Mother as I am Wife and what honestly still feels like Maiden some days. Duality reigns. As it should.

In today's modern world where women have become afraid of the depths of their darkness, they avoid the rage and anger that bubbles within. They are told to stay quiet and "put up" with what is, to stay in the box and that to be a "good girl" means to experience less pain. But does it?

To be human is to be a vessel for it ALL. Our light, our joy, our pure happiness, our self expression, and the seeking of what I like to call "whole-life-wealth" can only exist when we dance in the duality that makes us, us.

There is something truly beautiful about the journey home. The journey home to you, all of you, where your darkness is not obscured or fought, and you tenderly embrace the experience that was given to you the moment you arrived here, earthside.

My hope is that our granddaughters won't be forced to make the same pilgrimage that so many of us have. My prayer is that from the moment that first sacred breath enters their precious little body, they know themselves; that the holy rites of passage, void in the lives of so many women I walk beside today, are anchored and remembered. Imagine that world where we celebrate and hold sacred space for every pivotal turning point in one another's life. Imagine a world where instead of getting a new iPhone as you enter womanhood and the first droplets of blood fall, you are gifted with a circle where the women who have walked before you hold space for you, witness you, and hold your daughter's hand as she walks into a journey yet to be known. Imagine that world for a moment.

Do we dare be the ones who pick up the brush of remembering to paint our hearts out on the pilgrimage of walking ourselves home?

There is a blank canvas that awaits each one of us. This isn't a solo adventure, this work demands a Village. What happens when we put down the shield of

achievement and false drive to compete with men to be an "Alpha?" That is men's work, not ours as women.

Who do we become when we slow down just enough to hear what we couldn't yesterday?

To slow down is to remember. To slow down is to feel. To slow down is to be with ourselves. Most of our lives are spent void of that intimacy. Because love hurts. So we rush, we race, we resist, we fill our lives and selves with more and more, believing that that is what we need. Listening to the voices that aren't our own, pushing away our sacred ways and the unconditional love that flowed through us from the beginning.

Divinely created and when pristinely nurtured, our body holds the wisdom we seek to illuminate the path forward on this pilgrimage. Come walk with me…

Divinely Created

We are divinely created as Women—dare I say it?—with the most sacred purpose, which demands the utmost care and consideration from our beginning, until the end.

It should go without saying that our boys and men deserve the same reverence and be encouraged to journey through their own rites of passage. While the rituals that have occurred throughout the ages and across cultures have been rather a brutal and, I personally believe, unnecessary initiation for a young boy to cross in order to begin his journey of becoming a man, we have to remember that symbolism matters and a new iPhone or grade test doesn't, by any stretch of reality, make the cut.

Our bleed is a rite of passage, one that offers wisdom every single month.

Giving Birth is a rite of passage.

Breastfeeding our children is a rite of passage.

Our children moving out of home is a rite of passage.

Aging and no longer bleeding is a rite of passage.
And death is a rite of passage, into the realm beyond this one.

The sacred rites of passage that make us sacred beings have been all but forgotten. These are the ways that we must remember, for the sake of our mental, spiritual, emotional, and physical health.

What if we learned to fall back in love with our assignment and, in anchoring wholeness from the very outset, humanity changed?

What if we stopped hiding the truth of who we are through the filters, makeup, injections, and surgery?

What if we allowed our Human to shine? How would we deepen the connection between Self and Self, Self and the Spirit, Self and the Collective, Self and Mother Nature?

We must quit being raised on standards that we cannot uphold. The fallout is young girls developing body image issues and internalized trauma that affects their entire lives.

My body was the way I saw and related to the world from a very young age. For most of my childhood, I hated my body for letting me down and not being the representation of those perfect women splattered across billboards and double pages of my mother's magazines. I remember feeling as if I didn't know my place in the world, or how to behave. It was scary to grow up; the journey full of treacherous roads along cliff edges where, no matter how good the playlist was blasting through the speakers, there was no denying that shit was out of control.

No matter how many times I was told I was loved, trying to make sense of it all when that love, laced with shame and conditional approval, felt empty. For me, the only way to create control and "show" myself how much I could be a "good girl," was to manipulate my eating habits and exercise. I don't blame anyone other than the powers that continue to push an agenda that has women hate their bodies and mistrust themselves.

Above all else, learning to listen to the whispers from within, how to naturally nurture our bodies and trust the voice and way that is ours, should be how we are raised. Instead, from the moment our body begins changing, from when our menstrual cycle begins, we are shamed as if there is something wrong, something to hide.

"You're fat."

"You're too skinny."

"Your boobs are "itty-bitty. You should join the itty-bitty, titty committee!"
"You shouldn't wear that, go change."
"Don't say that, hold your tongue young lady."

My first recollection of beginning to hate my body was a rainy day in early primary school, when I was about nine-years-old. The same age my daughter is as I write this. Not daring to let my feet touch the ground for fear of the other kids finding me hiding in there, I curled up into a ball on top of the

toilet. The door was locked. I was eating my lunch in a stall in the girls' bathroom. This was just another regular lunch break. I even remember the little Tupperware container my mom had packed my tuna and celery in.

It only took one time. That one time I will never forget.

It was a rainy day where all students were kept inside to eat and play during the break. I opened my lunchbox. Then I opened the small container and the smell filled the entire classroom. Immediately all eyes were on me. Every single student, lead by one of the most popular boys in school began sneering "Eeewwwww that's disgusting! What are you eating? That stinks, are you a cat? Go outside and eat that. You're too fat anyway. You don't need to eat anyway. Go throw it away." Their looks pierced my heart; their words hurt more than I had ever known they could. It didn't matter how many times I was told while growing up that "sticks and stones can break your bones, but names can never hurt you." It was, in fact, the name calling and looks from the other children that spurred the compounding of my trauma.

If not in the bathroom, I hid in the cloak room at lunchtime, and cried as I ate my lunch. An experience that no child should ever endure, this was the real beginning of hating the body I lived in. I began asking *why*?

Why this body?
Why this food?
Why this face?
Why are they so mean?
Why am I being teased?
What did I do wrong?
What did I do to deserve this?

How can I change?
How can I fix this?

Internalizing what we do not understand as children is normal.

We need to understand that healing requires us to make peace with the ways in which our body protected us, the way in which she did what she had to in order not to be rejected from the tribe. We are, after all, primal beings.

At twenty-one I tried to "fix myself." At twenty-one I tried to change myself. I hinged a lot on those breast implants. I prayed that the surgery would change my life, that I would finally be loved. I obsessively dreamt about my life after those implants. I was no stranger to being completely consumed by thoughts surrounding my body.

Body dysmorphia is described as: "A mental disorder characterized by the obsessive idea that some aspect of one's own body part or appearance is severely flawed and therefore warrants exceptional measures to hide or fix it."

The neverending checking of my image in the mirror, fixing my appearance, going to extreme lengths such as severely undereating, over-exercising to the point of injury, taking laxatives for prolonged periods of time, exhausting myself mentally with counting calories and continuously thinking about whether my body gained weight that day… I lived like this through my teens and until I fell pregnant with my daughter.

Living this way steals every precious moment from you.

It is not sustainable; it is unloving and crushes you from the inside out.

And if this is you, I want you to know that I see you and feel the immense pain that you are carrying.

I was given twenty questions. Twenty questions to establish whether or not my mental health was stable enough to cope with the aftermath of going under the knife to change the appearance of my body. What the fuck were the doctors thinking? Approving a twenty-one-year-old, with a perfectly beautiful body, to go under the knife?

Personally I believe they weren't, and aren't, thinking. While there are absolutely sound reasons for women to get implants, mine was a mental health reason, not a physical one. And what I later found out with the birth of my two divine children, is that it cost me a nourishing postpartum journey and the ability to successfully breastfeed them. Which, to this day, I have still not made peace with.

Was I masking my truest expression of self?

Was I denying the divinity of my body?

Was I avoiding the natural curves of my body that society told me were too big?

Was I disrupting the love that could have been and protecting my heart from the pain of the assignment I was given to arrive here, in this body?

I feel that all of these are true. Today I can look back with years of perspective and wisdom. I pray that this wisdom is enough to encourage you or your daughter to avoid going under the knife like I did. And if you have, I pray this is the invitation you need to remove them and come home to your body, in all of her raw beauty.

The Japanese concept of Wabi-Sabi speaks to finding peace in imperfection, in the beauty of the effects of time, and in our flaws—the flaws of nature and that which is aesthetically beautiful.

What if we all lived by embracing *Wabi-Sabi*?

The Pilgrimage to Receiving Unconditional Love

"What do we need to survive Dad?"

"We need food, water, movement, shelter, and love. We need to love to survive."

My heart stopped, and immediately, I noticed where my journey to receiving love had not been unconditional. Instead, it was conditional on the chores I completed. On the mistakes I didn't dare make. On the grades I received. On my ability to fit in the box.

As I look at my children today, there is a piece of me that still finds it challenging to lean all the way in, to receive their love in the fullness with which they give to me. You might be asking yourself why and how this is possible?

Trauma is not what happened to us, it is the adaptation created from the trauma. When love is withheld from us, we withhold it from ourselves. Unconsciously, we then withhold love from others—our spouse, our own children. Leaning in hurts. It's true what they say: "Love Hurts."

It is not our fault that the act and art of receiving love in any and every form, feels shameful, punishable, unsafe, and wrong. The notion that pleasure was a punishable act has lived within our lineage for generations.

It is, however, our responsibility to learn how to let more love in.

Love, for me, is like a rollercoaster ride, where one minute the thrill of the drop picks me up and my belly finds its way into my throat, then the next minute I'm being violently thrashed against the side of a sharp left turn. I feel so at home in love. Here, there is familiarity; here, there is a constant connection to life force. It took me lifetimes to arrive here, and there are still moments that jolt me against the side of that rollercoaster carriage of love.

The moments that jolt me and have me catch my breath, are those orphaned parts of myself knocking hard on the door of unconditional love, waiting to be let back inside. As I glance over at that door, I find myself asking, "Do I dare open it? Do I dare let more of me in? Do I dare reveal more of me, to me?" Because once inside, who am I without the shield, swords, and armor? Ready

at any moment to fight for the stories that have protected me from love for so long?

Do I dare de-armour? Do I dare stand there… *exposed*?

It takes grace, compassion, patience, and perseverance to encourage my body to find safety in those longer hugs with my kids, in the expression of my soul with my husband, in those moments where I notice my body wants to flee the scene of what has felt like a crime—only to place my hand on my heart and remind my body, "It's ok, its safe to stay. Let's be here together. We don't have to run or fight anymore."

Growing up, I learnt that betraying my inner knowing, my authenticity, and my body was the only way to survive in this world as a young woman. Sacrificing myself for the sake of acceptance and inclusion, because "there is no other way" than the way that we have been told is "the way."

The way, that way, their way ignores who we are at our core. We have been told to ignore the very essence of what makes us a Woman.

Between my legs, covering that hiked-up school skirt between the maroon, black, and white tartan squares… there it was. In what looked like an abstract piece of art, I still remember it, that image forever tattooed on my mind.

Blood.

The shame rose within every cell of my body.

The tears fell.

I felt so alone, I felt scared, I felt sick.

Why is this happening to me?

The bathroom swirled around me, I couldn't think clearly and I had no idea what to do next.

How will I return to class?

How can I return to who I was before all this started happening to me?

I remember not understanding why this thing that we go through every month felt so foreign. *Why is there so much shame around it? Why is something that is so natural and sacred hidden away? Why, instead of slowing down to receive the medicine and wisdom that moves through us in this time, is it not honored?*

This was the second moment that deeply impacted my relationship with my body.

I hated the body I was in, not only was it fat and not keeping up with the other teen girls my age, it was now bleeding, bloating, making me angry, and I didn't know who I was supposed to be: out there, or in here.

Adding fuel to the fire and making me stand out to be bullied more, were my skin conditions. On my face, on my body, on my elbows and knees lived my eczema and psoriasis. On all the places that were seen daily. There was nowhere to hide. Every day was another day of struggle, another day of looking for ways I could camouflage myself, another day of staying silent, pushing love away, and in doing so, I continually exacerbated the undercurrent of stress I was living with.

"We need love to survive."

At what point in the timeline of humanity did it become more of a priority to make money, achieve accolades, and wear exhaustion and emotional unavailability as a badge of honor? It is no one's fault that this has evolved to become a societal norm; it is, however, our responsibility to rewrite what is not working.

Our environment has a direct effect on our internal landscape—we are, after all, nature. We are created to move in cycles, in seasons, and in pristine harmony with the world around us. This is by design. Who are we to fuck with the innate design of us and the planet the way we have?

When the habitat in which we live defaults to dis-ease, and the underlying frequency is one of stress and survival, it doesn't matter how well we "think" we are doing—ENERGY NEVER LIES.

As a Parent today, I have an ultra-heightened sense of what I am choosing over harmony in my body, in my home, in my environment, in places I frequent or choose to take my children, and in my relationships.

Knowing and nurturing the soil in which we are planting ourselves, matters.

Moving Beyond Survival to Return to Sacred Ways: *The Breath, Spirit and Survival*

As the chest expands and fills with nature's greatest gift to us, the belly follows as our life force expands. As the belly and chest fall with an exhale, the residual baggage that is not ours to carry any longer, falls away. Create space, give clarity, open our heart—and we remember. We remember our innate way of being, the softness that exists within us when we remove the pressure from the outside world, and presence and love enters the conversation between us and us. Body-led wisdom comes online.

Every child deserves to walk through life knowing the gift of their inner wisdom.

For a really long time, I didn't know what healthy relating was. I accepted the unhealthy relationships as normal because that was what the unhealed parts of me continued to attract.

I didn't know better because I had never truly known myself.

We can only experience the expanse of love to the depths that we have ventured to bring light to our darkest parts.

I held my tongue, allowed myself to be gaslit, and relaxed my boundaries for those who society told me would always have my back. Living in a constant state of fear was exhausting and it felt as though I was continually choking on the lump rising in the back of my throat.

That lump would whisper, over and over and over again, "Speak, say the words, dare to use your voice."

And I would swallow it down, convinced I was wrong.

Prepping myself for the moment when I decided to no longer be available for toxic relationships, to recognise the abuse (self or otherwise) that had been taking place for many years, took every fiber of my being. It took me landing back in my body and listening; finally hearing the ways in which I pushed my intuition aside. My trauma adaptations had protected me well. They dampened the whispers from within because if I had heard them, I would've rocked the boat so damn hard.

As my fingers hit the keyboard today, with the wisdom of birthing two children, traveling the world, and packing my bags for the adventure that is becoming whole again, not rocking the boat is even harder. I want you to know, dear child, that your intuition never lies, because when you are at home in your body, spirit has a clear channel through which to be heard.

Honor your body. Honor your way, and you will never go wrong.

What I have come to learn is that being self-honoring in a world where people-pleasing, perfectionism, and performing leaves so many women and mothers empty, disorientated, and resentful means trusting a life that isn't black or white. We aren't right or wrong, we aren't here or there, we simply are. With every twist and turn of the road, no matter the outcome of our decisions, no matter how lost we may come to feel, being self-honoring means always trusting the timing and path of our life. Especially in the face of our

conditioning that says, "You're behind," "You've made the wrong choice," "You are wrong." No, you are not wrong and nor am I.

The choices we make are meant to be made, for every hardship and challenge we face is placed there by God to develop us, to sturdy us and prepare us for what is yet to come.

How do we come to a place of trusting life when it has delivered what has felt like nothing but a constant dirty hand? How do we come home to Self and be at home in a body that we have hated, abused, and mistrusted for most of our life?
It takes time.
It takes patience.
It takes presence.
It takes breaking apart the armor and letting it burn in the fire.
It takes you bending down to lace your shoes and take the first few steps to walking the pilgrimage home.

Lose your way.
Come undone.
Say "Fuck it!" and punch the pillow.
Quit the unspoken bonds and expectations.
Trace your hands all over your body; feel the curves, the crevices and contours.
Walk away from the people, places, and things that break you.
Burn the sage and cleanse the air.
Enter the darkness, let the light be seen.
You're not wrong when you lose your way.
Home is where it all exists.

Mistrusting my body, avoiding Self, projecting my internalized and crippling shame, had many ways of presenting itself in the 3D. Promiscuity was one of them.

 I deeply craved to be seen, to be held, to be reminded of who I truly was at my core, to be connected soul-in-the-raw, to feel the wind at my back and the sun on my face—unconditionally.

What I have come to learn is that the depths of the valleys and the magnitude of the peaks in my healing journey could not have been escaped.

They were for me.

Avoiding them would mean that my daughter would be left with those chains around her ankles.

And I will not walk blindly, one foot in front of the other, in dishonor.

The chains of alcoholism that stole my Pop's last breath, the chains of unhealthy conditional relationships, the disempowerment of others, and the chasing of everything that will never matter in the end.

They all fall here.

While our behavior and expression of trapped and internalized shame may be a story that could be told differently, shaming is not ok. Ever. Today, I am conscious to apologize when I get it wrong, to correct myself and explain, "That wasn't what I meant—let me try that again." And no matter how painful, I do; I try again. While I know I will not leave my children "trauma-free," I will do my darndest to heal what I know is mine to heal and leave my daughter and son with the tools and empowerment to do the work for themselves.

It was the breath that gave me the space to hear my inner world and voice. It was the recovery work, the deliberate cold immersion through ice baths, and choosing to no longer consume alcohol. It was the strength that I recognised through a brand new lens I now possessed. I now had the space within me; loud and clear I was invited to take the lead.

This layer, this knowing, all began with breathwork; my very first deep-dive had me flying high and held in an out of body experience. Floating above my body, I looked down on me and recognised that this life is not all there is. Phew! If this life is not all there is, then is the way we are living and relating to our body all wrong ?

If our ancestors could see the harm we are doing to our precious vessel, the ignorance to the connection to Pacha Mama, and the sacred ways that connect lineages through time and space, they would shake their heads. And if we, as Modern Women, don't do something about it, our daughters will never forgive us.

I had been working with my Shaman for a few months when, after a specific energy healing session, I followed the nudge to head outside for a walk. With the sand beneath my feet and sweet music in my ears, instead of thinking and trying to cognitively figure out what I had just experienced, I moved it through my body.

As I moved, it was palpable how fast that energy was shifting and new internal pathways integrating. The rain began to fall. I ran faster and the rhythm of my feet carried me without having to think. The raindrops on my skin gave me full body chills, and as I landed back home and my bare feet hit the wet grass, time stood still. I dropped to my knees. That moment back in 2021 is forever etched within me.

The elements are medicine for our body and soul. The fire, air, earth, and water used by our ancestors to make magic and connect dimensions. How do we relate to the elements and feel them in today's world, where umbrellas keep the rain from our skin, where sunglasses, sunscreen, and clothes full of plastic prevent the sun from getting in? Where if the water is too cold, we don't go in?

We slow down.
We come home.
We learn how to listen to the whispers from within.
Our body has, and always will be, the way home.

I look around and see Mothers and Fathers on their phones—systems dysregulated, values displaced and true health replaced for false wealth. Sitting there in bodies that cannot stand sturdy and strong, that if needed couldn't run with their child on their back for more than a mile.

I see children eager to receive a loving glance, not just a nod of approval, for the sandcastle they have just built. Eager for a celebration and an embrace that lasts longer than the swipe of an Instagram story.

We've fucked up.
We've lost our way.
We all need to pack our bags and make the pilgrimage home.

We need present parents to weave sacred ways back into our lives of modern day.

Love Hurts

Loving oneself is a risk. Loving the curves, crevices, and dimples, the one breast that is now smaller than the other. Embodying a worthy and lovable woman beyond productivity, conditioning and achievement, revering the blood that streams down between my legs as it creates art in the bottom of the shower: is all risky AF.

Letting life love you, getting out of the way to receive his love, their love, unconditionally —yup, you guessed it—risky as fuck!

It's just like traversing the knife edge of a cliff path en route to the pinnacle of the pilgrimage—that is unconditional love: given, received, and embodied.

That edge feels like those times when I laughed so hard with my best friend that my stomach and cheeks hurt, where tears of joy streamed down my face and I wanted it to stop and yet, I didn't. I know you, too, can remember one of those times—picture it now.

Love is beautiful and brutal all at the same time and, beautiful girl, wise woman, you are worthy of it all.

And let me tell you, every inch of that treacherous journey of the cliff you're traversing, or have traversed, is worth it; every fall, every breath you catch, every stubbed toe, every time someone catches you .

ALL WORTH IT.

God didn't create The Universe to be without challenge; it was created in such a way to develop us, for us to know the assignment that can only live within being fully alive and in our body. Our body is the greatest gift of love. Learn to hear the whispers from within, she is the way home.

Go all in on her.

Don't hold back, don't want out—be here. As all of you, soul naked, in the raw.

What I am still learning today is that getting out of the way to feel it all, is the way home.

What I want you to know is that it is safe to move out of the way and let love fill you up.

It was the most painful thing to let my daughter love me.
It was painful to let my man truly love me, as I am.
It was painful to let the walls fall and let people in.

Sometimes today, it is still painful because I don't have to be anything or anyone other than me, and they love me. No matter how hard the day is, little H still pulls me in close to whisper, "I love you, Mommy," and time stands still.

Love is a funny thing; you know, when they say, "love hurts," they mean it.

I believe it hurts because we armor up and choose alliance to our stories over vulnerability, because dismantling those stories means being wrong.

I believe it hurts because we have traded depth, sacred connection, and pure love for surface level appearance, disconnection, likes, comments and follows.

I believe it hurts because what was once the Village where our ancestors lived, is now a dispersed, isolating landscape where some of our most innate ways are violently shoved aside.

I was lovable all along. You are lovable right now. And you are loved, in this very moment, exactly as you are. Love does hurt, but in all the most incredible soul shaking and satiating ways. When you let it in, that is.

I pray that this finds you and loves you where you are at.

Remember, the body is the way home. You can let go of control and let her take the lead.

Walk whole x

Body Wisdom
Weaving sacred ways into modern day.

> "The soil is the great connector of lives, the source and destination of all. It is the healer and restorer and resurrector, by which disease passes into health, age into youth, death into life. Without proper care for it we can have no community, because without proper care for it we can have no life."
>
> - Wendall Berry

I have come to learn over time that the journey to Becoming Whole Again—of healing—is more about a return to what has been forgotten; it is about remembering from where we came and to where it is that we will return.

Life is the brightest thing in the Universe; your vitality is your responsibility.

> "What is the difference between physics and life? Life is 10,000 times brighter. Life is 10,000 times brighter than a star. Who are you? You are the brightest thing in the galaxy. You are here to light up the cosmos."
>
> - Zach Bush

How then, do we trust in our remembering and embodying of the undeniable fact that we are the brightest star in the cosmos?

Zach Bush speaks about light energy being held within water structures, and perhaps this is why submerging myself in ice cold water over the years has provided immense healing. The cold gives us what our head cannot. This too is why your hydration matters when coming home to the deepest truth of who you are; you are mostly water!

What I have found to be the fastest way to unshackle the chains of pain and shame from around my ankles has been through the body. I believe that

coupling our thought and journal work with devotional sacred practices—and then moving it all through the body with somatics—allows the nervous system to relax and find safety, allowing the body to finally let go.

It is here that a full body exhale is realized and the lens through which you relate to your past changes. A fresh perspective and way of being is embodied.

Learning how to harness the power of presence through our breath and the cold offers us the ability to handle sensations that we would otherwise run and hide from. Alongside this, when we devote ourselves to cultivating a harmonious and healthy inner landscape, we collapse time around our healing.

Here are some gentle and simple invitations to support you in beginning your journey:

1. Happy gut, potent intuition, sturdy voice

Beyond our five senses lives what some refer to as our original sense—our intuition. This is our compass, and when we are deeply attuned to the whispers that move from within, our voice is sturdy because we are rooted in deep self-trust.

Here, I invite you to begin to raise awareness around what is happening within, to learn how to hear your intuition again:

1. Notice.

2. Listen.

3. Decide.

4. Reassure.

5. Move.

1. Notice the cue.

2. Listen to what it is asking of you.

3. Decide to follow through on honoring that cue.

4. Reassure yourself it's safe to not suppress, run, or hide. Reassure through creating containment.

5. Move in BODY DEVOTION.

These steps are simple.

Trust me, they work.

When beginning to learn how your body speaks to you, notice where you are not offering her nourishing foods to optimize a healthy microbiome. Not only does our microbiome support our digestion, it is the great communicator in our body. From our central and enteric nervous system, to our neurotransmitters, to our endocrine system, to metabolic and immune support.

Here, I invite you to take a gentle inventory of the way you are feeling in your gut, to the way you are sleeping, to the way you wake each day, to the foods you choose to nourish your body, and the way you move—it all matters.

Life is the brightest thing in the Universe; your vitality is your responsibility.

2. Get to know the cold

Begin your journey into the cold through adding gentle and intentional moments of cold while in the shower. This may look like 10-20 seconds where you take a few slow breaths and remind your body she is safe, exhale intentionally: then move into the cold stream of water.

In the beginning, you may only feel safe enough to have one shoulder in the cold. Maybe after a few days, it feels safe for the entire front of your body to venture in, then after a week, your body relaxes and welcomes you to be fully immersed.

On the days where you go into the cold, notice where you become clearer in thought. Notice if your sleep deepens and/or your ability to respond rather than react enhances. Notice where you might have taken on a renewed pace and perspective.

3. Hydrate your body, hydrate your spirit

Your hydration matters. Research recommends that we need to consume 8oz per waking hour for the first 10 hours of the day. Then 5oz/hr thereafter; this is independent of exercise. Remember, water in your blood doesn't have the same potency as hydrated tissues.

Follow the recipe below to ensure you're hydrating to water the rich soil in which you stand:

> 23oz of filtered water
>
> 10oz of coconut water
>
> Juice of a lemon

½ tsp of celtic sea salt or pink himalayan salt

1 tbsp of maple syrup

Stir, sip and enjoy!

Spiritual hydration matters too. It helps us to hear beyond our thoughts and allows God/Spirit/Source to enter the conversation with us; having a relationship with a power greater than ourselves allows us to let go of what is not ours to control and follow the lead of our heart.

The Serenity Prayer has offered me peace over recent years, and I offer it up here for you to bring into your daily devotion practice or repeat in the moments throughout your day that may feel heavy or out of control. Place your hand on your heart, take a deep slow breath, and repeat until you notice your body soften:

God, grant me the serenity to accept the things I cannot change, the courage to change the things I can, and the wisdom to know the difference.

Within my chapter I pose many questions along the way, I am sharing those again below to encourage you to explore some of what comes up for you on the following journaling pages.

1. QUESTIONS SHARED :

Do we dare be the ones who pick up the brush of remembering to paint our hearts out on the pilgrimage of walking ourselves home?

Who do we become when we slow down just enough to hear what we couldn't yesterday?

QUESTION TO PONDER : What does remembering mean to you? What needs to change, to be let go for you to slow down to begin to hear the whispers moving from within you?

2. QUESTIONS SHARED :

What if we learned to fall back in love with our assignment and, in anchoring wholeness from the very outset, humanity changed?

What if we stopped hiding the truth of who we are through the filters, makeup, injections, and surgery?

What if we allowed our Human to shine? How would we deepen the connection between Self and Self, Self and the Spirit, Self and the Collective, Self and Mother Nature?

QUESTION TO PONDER : Who is the human behind the mask, the one you are hiding, do you know? Would you like to get to know her, the real her? What does it mean to you to become the ripple in the pond of healing, that by leaning in to heal yourself, you heal the world?

3. QUESTION SHARED :

The Japanese concept of Wabi-Sabi speaks to finding peace in imperfection, in the beauty of the effects of time, and in our flaws — the flaws of nature and that which is aesthetically beautiful.

What if we all lived by embracing Wabi-Sabi?

QUESTION TO EXPLORE : What might be created within you and within every day if you lived by embracing the concept of Wabi-Sabi?

4. QUESTION SHARED :

How do we come to a place of trusting life when it has delivered what has felt like nothing but a constant dirty hand? How do we come home to Self and be at home in a body that we have hated, abused, and mistrusted for most of our life?

QUESTION TO EXPLORE : What does trust feel like to you? What would it mean to you to trust yourself, your body and life again? Where would you take that unshakable trust?

The truth will set you free, but first it will piss you off
Gloria Steinem

♡

CHAPTER TWO

If This Body Could Talk, It Would Tell An Amazing Story

As his hand traces up the curve of my hip, along my waist, and settles on my breast, I feel an electric current move through me. I feel the pressure of his hard body on top of mine and can tell he wants this as much as I do. His crystal blue eyes connect with mine and I can feel his warm breath on my neck as he whispers in my ear, "You are so beautiful." As his lips gently bite and tease the soft spot on my neck, I feel a pulsing and warmth directly in my core. I can no longer think rationally; my only thought is how much I want him between my legs. As he slams into me hard, I gasp and lose myself in his intoxicating embrace, whispering all the things I want him to do to me. I'm saying words and begging for things I never imagined I'd want, let alone say out loud. But in this moment, nothing exists apart from our sweat-covered bodies, and a deep desire to feel him deeper within me. My eyes close and my body takes over as it arches back and pushes against him. I can't think. I'm lost in a bliss that's…

As I see movement out of the corner of my eye, I glance up from my book. I'm sitting on my bed immersed in my guilty pleasure—reading a romance novel—trying to wash away the stressors of the day. My daughter, Sophie, has come into my bedroom. I go back to reading and notice in my peripheral vision that she is making a repetitive movement. As I tear my eyes off the page, I see that she's looking in the long mirror, wearing just her underpants. Her seven-year-old body is all long limbs. From her skinny legs up to her teeny-tiny belly, you can see the faint line of her ribs as she moves her body. Her little hands are placed on her flat belly. Standing sideways, she pokes her belly out, then in, then out, then in. No longer able to ignore the movement, and with curiosity arising in me, I ask her what she's doing. I figure it's a game she's playing. The words that come out of her mouth are a shock. Ok, that's an understatement; I feel the floor drop from underneath me and panic rises in my chest as she replies, "I'm fat."

I cannot believe it. I can see her ribs sticking out, as she hollows her belly in toward her back. My retort is reflexive as I jump to defensive mode. I'm not thinking rationally. I'm devastated. Sure she can see the blood drain from my face and my jaw drop, I tell her in no uncertain terms that she is definitely not fat, and it's not about how we look but about how we feel. We have a rule in our house—we do not talk about how people look or their appearance—because I know first-hand how damaging that can be. To be honest, I can't remember exactly what else I said, because I was in shock. *How can a seven-*

year-old who is clearly not fat, think that she is fat? In that moment, I feel like I have failed her. I haven't been able to shelter her from the pressure placed upon us to look a certain way. She obviously senses my disappointment because she back-pedals, saying she was joking. But I know she's not. Her revelation has sent me into a tailspin.

The next day as I'm getting dressed, I glance at my figure in the mirror. I turn to the side and inspect my profile. I'm disappointed. In the last six months I feel like I've put on a lot of weight. My once flat stomach is now protruding from underneath my breasts. So I pull my stomach in, using my hands to push it in so it goes flat. Unable to hold my breath in any longer, I release my stomach back to where it sits comfortably. And I think to myself, "I'm fat."

In that moment it hit me. I'm a fraud; a hypocrite. What I told my daughter yesterday was true for her. But not for me. I have one set of standards for her and everyone else, and another for myself. It's not about how other people look, but it matters how I look. The words I teach my children are merely lip service, and I feel lost. How can I expect them to achieve an acceptance of their body when, at almost forty-seven-years-old, I can't either.

I don't know what to do, so I decide to strip off my clothes in an attempt to get to know my body. It's hard to look at the way it's changed over the years. No longer tight, smooth, or thin. Standing there in front of the mirror is confronting and I feel uncomfortable and self-conscious, even though it's just me standing there. As self-judgment and disappointment rise in my throat, I swallow it back down, close my eyes, and take a deep breath.

Breasts

When I open my eyes, my gaze and hands slowly move down my body and settle upon my breasts. In my twenties and thirties, they were propped up by padding and push-up bras to get some shape. But today they are full and more than ample. One is slightly bigger than the other, which strikes me as odd.

My mind wanders to the last time I saw my sister. She was in hospital, recovering from a ten-hour operation to remove both of her breasts. As we walked down the sterile hospital corridor to see her, I was gritting my teeth, and my body was completely tense. I was afraid of what I would see when we opened that door. *Would she look like a former shell of herself? Would she be in pain?* Counting down the room numbers as we went, it felt surreal. *How could this be happening?* When we found her room, I pushed the door open with trepidation, quietly calling out to announce our arrival.

Sitting in a chair, she has tubes hanging out from all areas of her body to drain the fluid. The tubes are filled with yellow and red liquid, and she has

a catheter connected to the bed. She's taped up and restricted, and tells me that she hasn't been able to see her breasts since the operation. The double mastectomy and breast reconstruction was the final step in her nine-month battle with breast cancer. Her smile is wide, her voice sounds the same, she's laughing and taking this all in her stride. But I know this has taken its toll on her. I know it has changed her; I can see it in her eyes. And how could it not? Fuck cancer. I swear I have said that a million times since she was diagnosed.

Her hair is growing back and I'm struck with how similar she looks to my mum when she was recovering from her chemotherapy treatment. My mum was sixty-three when she was diagnosed with breast cancer. They both fought, and won. I'm so proud of them. My mum, my sister…

As I'm brought back to the present, I look down at my breasts and can't help but feel a little scared. My journey of self-exploration has turned into a breast examination. Since my sister was diagnosed, I'm constantly checking my breasts for lumps, and worried when they hurt before my monthly bleed. I'm terrified that they could be a death sentence to me. I had never felt a fear of dying, however having children has changed that for me. The preciousness of life is apparent when they tell me that they don't want me to die and leave them alone. It breaks my heart to know that one day I won't be there to hold them and tell them that I love them. They feel the fear too.

It all feels so out of my control. *Could I be next? Could these breasts I'm gently holding be a ticking time bomb?* It's so ironic that the part of me that is created for nourishment of life is the very thing that could take my own. I've tried to take back control by putting a monitoring plan in place, making changes in my lifestyle and environment, and moving past the fear. I'm taking all the precautions you can possibly imagine, and while I know in my head that their fate does not need to be mine, my mind wanders occasionally to the sad truth—I don't trust my breasts not to kill me.

IVF and Fertility

My hands keep wandering down my body to my middle. As I rub my bulging belly, I can still see the scar from my belly button piercing that was taken out almost twenty years earlier.

In that moment, I'm travelling back in time and can see a stomach filled with bruises. This stomach has endured hundreds of injections as a result of IVF treatments. While we are now blessed to have two beautiful children earthside, our path to get here was traumatic to say the least. I'm filled with sadness, resentment, disappointment, and grief, as I reflect on our seven-year battle with infertility and pregnancy loss.

I also cannot shake the guilt that bubbles up every now and then—the little voice in the back of my mind that questions, "Was this all my fault?" It's amazing how clear things become with hindsight and, looking back now, it makes sense that we struggled. I met my husband a little later in life, and when we married at the age of thirty-three, we were excited to start a family.

I had been taking contraception since I was seventeen-years-old, so the thought of no longer controlling my monthly cycle felt like freefalling out of a plane with no parachute. For sixteen years I manipulated my bleed. I would even skip the sugar pills to avoid bleeding if it wasn't convenient. In order to control acne breakouts, I was on the highest dosage. Completely naïve, I didn't know the long-lasting effects it could have on my body. *Did this cause my infertility?* I couldn't tell you for sure, however I do believe there are risks in trying to control your hormones against your body's natural rhythm and intelligence. And as an aside, I will definitely be discouraging my daughter from taking it!

By the time I stopped taking the pill, I had no idea what my cycle even looked like. Yet I expected my body to get on with it. I expected it to know what it was doing after years of me sitting in the driver's seat and controlling the shit out of it.

After six months of trying to become pregnant, I was frustrated. My cycle wasn't regular and there was nothing I could do to force it to comply. So my husband and I saw a fertility specialist. Once again, I sat back in the driver's seat, because I didn't trust my body to get the job done. For the next year-and-a-half, I did everything to force my body to conform. It became a source of experimentation; from invasive surgeries, to different drugs, to different diets, to acupuncture, to homeopathic remedies—we tried everything. But it kept letting me down. All attempts to control it fell upon deaf ears. It was heartbreaking and exhausting.

And as I struggled to gain control, the biggest bombshell of all was dropped on us. After another run of tests and an exploratory surgery, we found ourselves sitting, yet again, in front of our fertility doctor, waiting for the verdict. As we sat down, bracing ourselves for the results, I was excited and scared at the same time. My palms were sweaty and my heart raced. You don't realize how much you want something, until you're told it may not be a possibility. And in that moment, I felt terrified that we could end this whole journey without a baby in our arms. I knew the result as soon as I looked in his eyes. He shook his head and said that they hadn't found anything wrong, and that our best chances of having a baby of our own was to use a surrogate.

It felt like a sick joke. I, a self-confessed control freak, very much Type-A personality, was being asked to hand over control and entrust my baby-

carrying duties to someone else. I had dreamed of being pregnant for so long, and now it would never become a reality.

I was embarrassed that my body couldn't do what it was made for; I felt unworthy and less of a woman. It was the ultimate betrayal because, once again, I couldn't trust it—it had let me down. Or maybe deep down there was guilt, because perhaps I had failed it?

Over the next two years we endured nine IVF cycles, a miscarriage, and eventually ended our surrogacy journey with a baby boy in our arms. Luca finally graced us with his presence. Five years of our life was spent creating this little life. We controlled the whole process—he was created in a laboratory using my egg and my husband's sperm, and implanted and grown within someone else's uterus. And while I am grateful we had the means to do this, I still feel a pang of disappointment that I wasn't able to experience his creation in the way I had pictured.

Pregnancy

I'm brought back to the present moment as my hands keep moving down my stomach and trace the curves of my caesarean scar. It's numb, which is similar to how I feel about its existence. Just weeks after Luca was placed in my arms, my period went missing. And while I wasn't optimistic, I found myself in the bathroom nervously awaiting the result on a home pregnancy test. A test I had taken and failed a million times before. Shock and disbelief don't even come close to describing my reaction when the test revealed two lines. I was pregnant! After years of being at war with my body, trying to control it, and being disappointed at every turn, maybe it could actually do something right? Perhaps this was the turning point?

Nine weeks later our bubble burst. The words, "I'm sorry, there's no heartbeat" at our ultrasound appointment shattered that trust, yet again. It turns out my body couldn't do it. It was rejecting the chance to grow that little baby. I could sense my husband's disappointment and felt guilty that I had caused this. We drove home in complete silence, each of us trying to process this as best we could. I was numb, and felt even more detached and betrayed by my body. Even today as I think of that moment, tears of anger and disappointment well in the back of my throat, threatening to spill over. It was such a senseless loss. A cruel test.

Six months later I found myself once again taking a pregnancy test. It was positive. This time, instead of excitement and hope, I felt fear and anxiety. Over the next nine months, my body miraculously grew this baby but, by that time, the damage was done. I had disconnected from the process. I was moving through the motions of this pregnancy but I knew that at any moment,

the rug could be pulled out from underneath me again. I didn't feel the hallmark emotions you're supposed to feel. I couldn't picture holding my baby in my arms; I was waiting for the other shoe to drop.

As my finger moves across that scar, I so clearly remember the night that Sophie arrived. It was midnight and I was laying in the bath unable to find any kind of relief. My husband was asleep, as was Luca who was seventeen-months-old by then. After hours of discomfort (and my husband telling me to just try to go to sleep), I called the hospital, worried that something was wrong. I knew that this wasn't normal, and my husband's dismissal and ability to sleep through my pain infuriated me. I was scheduled for a "c-section" a week later, due to our little girl being in a breech position. They told me to come in so they could check that everything was ok.

Thirty minutes later, as I lay on the hospital bed, I could feel the nausea rise inside me. With a hospital vomit bag firmly clutched in my hands, nothing was staying down. The pain was too much. Hooked up to machines that were beeping and buzzing, a nurse came in and held my hand. She gave it a squeeze, then gently guided it down low to my bulging abdomen. As she placed my hand in position, she said to me, "Do you feel that?" Through my delirious state, I was able to make out a tightening and shifting underneath my hand. I nodded in reply. "My dear," she said, "that is a contraction. You're in labor."

Everything moved quickly after that. By then it was 2am and a delivery suite was free. So, with zero warning, they announced that this baby was coming out now. I looked over to my husband, Craig, who was nursing a sleepy little Luca. We had no one to come and sit with him, and there was no time left. I was going to have to do this by myself. After saying my goodbyes, they wheeled me down to the operating theater. People were running everywhere setting things up as nurses and doctors asked me questions. By the time they administered the epidural into my spine, I had gone into shock.

Things were completely out of my control and I had disconnected from my body. I could feel the impact of the tugging and pulling but I was numb, both physically and mentally. When they eventually placed Sophie next to my head so I could see her, I was shaking. I looked at her, nodded, and in that moment, I felt nothing. Zero connection, zero recognition, just a coldness that seeped into my bones.

Sexuality

As I reflect on that coldness, my fingers trace the path from my scar, over my pelvis, and hover over my vagina. I don't allow my fingers to touch the folds of my skin. I want to, but something prevents me from embracing the power

of my sexuality and femininity. I crave being able to touch myself with the rawness, sensuality, and pure animalistic instincts I read about in my erotic novels. *Perhaps that's why I read them?* They export me to another place where there is no shame around arousal. Where you can let go of your inhibitions. Where you can lose control.

I know where this resistance comes from, as my mind wanders to the first memory of feeling shame for using my body to provide me with pleasure. I'm around five-years-old and, as I walk out of my bedroom and snuggle up beside her on the couch, my mother asks me, "Have you been doing the naughty business?" No, I shake my head honestly and feel my face heating with shame.

My mother is referring to me pleasuring myself. It had been labeled as something that we do not do, and it was a punishable offense in our house. My "naughty habit" was spoken about in hushed tones with doctors and our friends, and that sent me a clear message. It wasn't normal, it wasn't okay, and there was something wrong with me. I felt so embarrassed and still do, even writing this.

This is by far the hardest part of my story to write. Even as a grown adult, I know there is nothing wrong with self-pleasure. In my logical mind, I know that it's normal and healthy, but I cannot lift that veil of shame—the seed that was planted in the back of my mind, telling me that there was something wrong with me. It's as if my sexuality and femininity blossomed within me at such a young age, and that flame of desire and ability to embrace my womanhood was doused in water before it had time to grow any larger. From then on, I hid any kind of pleasure or release I had because I thought it was wrong.

In addition to the shame around pleasure, close family members had been victims of sexual abuse, which was spoken about at length. My mother tried to protect us as much as possible but the message was there. Sex was to be feared. We had to protect our bodies and be on high alert because, if we weren't careful, our innocence would be taken.

I think back to all the messages that little girl was given when she was so young, and I want to hug her. She was led to believe that her pleasure was dirty and something to be ashamed of—but it wasn't. She was told to distrust the messages that her body was giving her because they made her different. She was told to shut down, live in fear, and close herself off to protect herself. That little girl deserved better.

Throughout the years, those messages were confirmed over and over again. Sex meant betrayal from those you were supposed to trust the most.

And I had also fallen victim to betrayal. I'll never forget the night my (then) husband came to me and told me he had been cheating on me. He was the first man I had ever been intimate with. I had waited until I was nineteen to lose my virginity—it seems so young now, but at the time it felt like I was an "old maid." While my friends at school were all sexually active, I held it to my chest, unable to get past the fear of letting someone in. But I gave my body to him, a gift (although I didn't appreciate how special that was at the time), and he took the little trust I had left and trampled all over it in a *big* way. It wasn't just my heart he broke that day. I felt so foolish. I had opened myself up to him and been vulnerable, and it had been thrown back in my face.

So, I closed my heart off and decided to take back control in the only way I knew how. I took back the power that had been stripped from me. From then on, I was out to prove that I was, in fact, desirable. I used sex as a weapon. To manipulate. To prove my self-worth.

It turned me into someone I didn't like. "Promiscuous" would be a kind way to describe it. I didn't care if I was with a married man or someone I would never see again—in fact, that was preferable. There was no risk of being betrayed, because it was just sex. For the next five years, I lived emotionally shut off and disconnected from my body. It merely became a vessel in the desperate need to find a sense of self-worth and power. Sex became my armor; a façade I hid behind. The only pleasure was found in the control, not the act itself. It wasn't about passion, or sensuality, or even pleasure—it was merely a performance with fake orgasms to boot. And because it was a quick rush, it became an addiction. But the next morning, I would always feel a wave of shame wash over me. It wasn't power the next day. It was just sad. I had allowed my body to be used.

Body Image

As I lean over, my gaze settles on my thighs. I feel turmoil and conflict. I hate my thighs and cannot remember a time when I didn't. To me, they look solid, and when I try on my clothes, that is where my gaze settles. My head tells me that it doesn't matter what they look like, but my reaction is so ingrained that I can't get to that illusive "body love" I crave so much. I can't remember a time when I was not at war with my body, trying to manipulate and control how it looked and behaved.

It started when I was five-years-old when I followed in the footsteps of my two sisters and started ballet lessons. As you can imagine, the pressure to look a certain way is immense. And when you're wearing nothing but a leotard, pink tights, and ballet shoes, there is nowhere to hide. You're completely exposed. Every single muscle, arm placement, and pirouette is scrutinized.

I remember watching the older girls in our dance company in awe. The best dancers won all the medals at our competitions, and gained the starring roles in our end of year concert. I dreamt of being them. But they all had one thing in common—they were painfully thin. You could see the outline of their ribs through their leotards.

Our teachers would constantly comment on our appearance without worrying about whether we heard or not: "Her thighs are too big." "She's put on weight over the Christmas break." "That one doesn't have a dancer's body." The message was clear—in order to make the cut and be successful, you had to be thin.

Over the eighteen years I was a dancer, I was taught that my body was something to be controlled. Every arm movement must be in the correct position. Use the exact amount of force and flow. Engage the right muscles. Push your limbs beyond the point of pain in order to be flexible. The more control you maintain, the more beauty you create. And in order to maintain that control, I worked out hard and often. If that didn't allow my body to look how it was supposed to, I turned to food restrictions.

Dieting was the norm in our household and in the circles I traveled. And regardless of the fact that I have always been thin, I still tried every fad diet imaginable. The craziest ones included only eating vegetable soup and bananas or carrots, or whatever food was "allowed" depending on the day of the week. Looking back, I have no idea why this particular diet dictated such specific foods on each day, but I didn't care if it was safe, just that it worked. I cut out carbs whenever possible and would often just eat a plate of vegetables for dinner.

Even today, I constantly think about my weight, what I'm eating, and how I look. Despite the "no diet" policy I have put in place, and the fact that I no longer own a set of scales, I still can't escape that little voice that whispers in my ear, "You shouldn't be eating that bagel. No wonder you aren't happy with the way you look given that bowl of ice-cream you just ate."

It's an ongoing battle to break the habit and messages that were planted inside my head at such a young age. I find it so sad that I have never been satisfied with how I look in the moment. The other day, as I was scrolling through photos on my phone from six months ago, I was stunned to see I was thin back then. But at the moment that photo was taken, I recall thinking I was fat. It's so confusing. Like an optical illusion, I can't tell whether the disappointment with my body is just my mind playing tricks on me, or the truth.

I never used to understand why people who had anorexia could look in the mirror and think they were fat. But now I do. I have been conditioned to think I am overweight at every size. To feel dissatisfied and feel the need to change and control my body, no matter what.

The Realization

As I sit here pondering what this all means, a deep level of understanding washes over me.

It's no wonder I'm unable to let go and truly connect with my body.
It's no wonder I'm constantly disappointed with how my body looks.
It's no wonder I constantly feel like I'm at war with my body.
It's no wonder I feel let down by it and like I can't trust it.
It's no wonder I feel the need to put up my walls and protect myself.

Because it doesn't feel safe.

There are so many voices in my head, screaming at me all at once. But most of all I hear that voice in my head telling me to stay in control. Do Not Let Go!

As tears stream down my face and understanding seeps in, I feel completely exposed and raw, but I also feel free. For so long I thought that there was something wrong with me. That I was broken beyond repair. I have been swimming in a pool of shame and self-doubt. I have held that fear deep inside. My reaction to all this has been to push it down, hold it in, to internalize it all. And I have been doing this for so long that I never noticed how much it was weighing me down. But I now have a clear realization that these beliefs were never mine to carry.

Those fears belonged to someone else.
The shame was misplaced.
That betrayal was never about me, or because there was something wrong with me.

The unreasonable expectations that were placed on me were based on outdated messages passed down from those who didn't know better. It was about commercialization, and trying to put me in the same box as everyone else.

Because the truth is that I am not broken, and nor are you. It's up to us to rise above the voices and tune out what is not ours. To put down the burdens that don't belong to us.

And, while travelling down the path of my body and the tales it has to tell evokes such sadness in me, I don't feel like I am a victim of my circumstances or the mixed messages I've received over the years. In fact, it makes me feel even more powerful. I am so proud that I can finally see through all the bullshit.

Because the reality is that my body has endured and survived a lot more than I give it credit for. My body tells an amazing story; it's a roadmap of tightly interwoven pleasure and pain and shame.

On my wrist is a tattoo. I got it to represent my babies—those who made it into my arms, and those who did not. Each time I look at it, I'm reminded of the grief, struggle, endurance, strength, vulnerability, determination, and pride I hold for all my body has endured. Because I don't want to forget. Because this is part of me.

Today, one of my greatest fears is that I am perpetuating this cycle of body shame. I am a disciple of it because I haven't been able to break free from it. I fear that I am teaching this and passing all of these unhealthy messages onto my children. This is why my reaction to Sophie's revelation was so extreme. Because if the load I have been carrying for so long is not mine to carry, it's sure as shit not my children's to carry either. And I'm going to do everything in my power to ensure they are free from this. That you are free from this.

Don't get me wrong, I am not completely whole just yet. I still crave the ability to become one with my body and trust that I will be safe. Safe from self-judgment and societal expectations, safe from hurt and pain. I want to be able to lose myself in the simple acts of sex, meditation, breathwork, or dancing, without worrying about what people are thinking of me or what I look like.

I'm still in the messy middle, and this story is still being written. But I'm untangling it. I'm rewriting it. For me. For my children. For you.

Today, I'm learning to let go little by little. I'm following the breadcrumbs, knowing that they will lead me back home…to me.

The Body Trail

"I can't remember a time when I was not at war with my body, trying to manipulate and control how it looked and behaved."

This realisation is devastating. But what is more disappointing is that I know I'm not alone.

As women, we have been conditioned to think that beauty is all about the shape of our body, and how we look. We've been brainwashed into thinking that this is the most important thing. In truth, it's a ploy to keep us distracted from stepping into our true power as women (but that's a whole other story!)

Because of this conditioning, we spend so much time pointing out faults and imperfections in our body that it becomes a habit. We focus so much on all the things that it isn't doing to support us, and all the places where it is letting us down, that we forget all it is doing, or has done, for us over the years.

My hope for all of us is that we can block out the noise and the messages we've been told about how we should look. That we stop punishing ourselves and, instead, get to a point where we have respect for our body. Where we take care of it, protect it, and nourish it because that is what it deserves, instead of trying to manipulate it to look a certain way.

I'm careful not to say the words "body love," because for a lot of us, that feels a little too hard and icky. If you can get there, good for you! But for now, let's aim for something the late Aretha Franklin taught us—R E S P E C T!

Take ten minutes to go down your body—you can do this in front of the mirror, or not. With clothes on, or without—whatever feels comfortable for you.

Start at your head, and work your way down. List all the ways each body part has supported you, and continues to support you. Focus on the functionality of it i.e My *arms allow me to hug my loved ones*, or, *My feet keep me grounded and take me places.*

Feel free to use the following journal pages to capture this and answer these questions:

1. What has your body endured?

2. What is the story it would tell if it could talk?

3. What are some things you've been punishing your body for, that you can release?

4. Are the expectations you've been placing on your body too high? If so, how can you lower them and give yourself a little more grace?

5. What are some things you can do to support your body?

She lost herself, a little, in that darkness but returned with stars beneath her skin

Blake Auden

♡

CHAPTER THREE

Healing To Be Seen
Releasing the Chains of Shame

In the mystery of life, I found my spirit. Ready to lead me through the trenches of deep grief into self awareness and, ultimately, to the sacredness of love.

Often alone, yet never alone. The veil was lifted, at a young age for me, when I saw beyond my years. As I grew older and more aware, I kept quiet, only sharing my visions and my wisdom with my mom, my husband, and then with my close circle.

Today, I am sharing my story of healing with you. It is my declaration to inspire you to fully move into spirit and share your unique gifts with the world.

I look at my daughter, who is now nine-years-old. Strong, beautiful, yet still so young and innocent. Doing my best daily to give her a different experience than mine. Living in a loving relationship with her father, my husband. Fortunate enough to have the foundational support from his family and him to show up for myself with self-care, I have created the space to witness my daughter "be." Loving and open to listen to her fears and worries, and hopefully, help her navigate this world so she too can *be seen*.

In meditation, I found her. *Curled up in her closet with a journal and pen in hand, she sat in sadness, numb to the outside*. It had been a few years since her world collapsed. Witnessing my younger self alone in the closet, I read the journal page she sent through the meditation transmission: "Now is the time, it's GO time. Tell our story. Share our truth, it will set me free."

Rebuilding in grief is nearly impossible. *The letters with the return address from a state prison, eight hundred miles away, sat in a box next to her in the closet. The daughter of an incarcerated father left to sort life out without the dad she loved so much.*

Unnoticed

Shy to the outside world, my insides stirred with emotions. My grades in school were below average and I went unnoticed in class. I felt like an old soul among my peers. I felt much deeper, perhaps they did too, it's just that we didn't know how to communicate with one another.

Maybe school was a time where you felt cloaked beneath invisibility while deeply desiring to be seen for who you truly were?

Stirring in my belly for years, those internally-held emotions became outbursts directed at my mom, "I hate you! I want to live with my dad!" I said a lot of hurtful things to my mom. My internalized invisibility, externalized with hurting the one person who was always there for me.

What I was really seeking was to escape my racing heart and sensory overload in my body.

Now a mother myself, not only do I understand and hear my kids when they need an outlet, I feel my kids' frustration, sometimes before they do. Supporting them through a few rounds of breathwork, or tickles to get their body moving, is always a good idea in our home.

What is frustration but bottled-up emotions, unable to escape?

Engraved Memories

After a phone call with my dad, we all agreed that I would move in with him, eight hundred miles away in Arizona. For the first time since my parents' divorce at the age of two, I spent eight months living with my dad. It was a huge adjustment for us both. My dad, an insurance broker, brought his nine-year-old daughter into his bachelor townhome. We ate a lot of pizza and the fridge was always stocked with original yellow Gatorade and popsicles.

I have great memories of him teaching me to swim, going to the activity park, and playing foosball. My dad, highly intelligent and influential, shared with me his take on life: "With hard work and dedication, you can make anything happen. Be bold!"

As we watched the night sky, he would share his stories of abductions and alien encounters. He talked a lot, building up dreams and future manifestations for us. My dad revealed his childhood with stories of abuse and how he became a better man. He spoke about his career and business investments with conviction.

How many of us see our father in the hero's light?

I can also recall that's where my intuition increased, again out of survival. Although my dad was always good to me, he kept secrets, and towards the final months of living with him, something was wrong. I could feel it in my dad, in my body, and in the house.

You know the feeling: gut stirring, hard gulping in the throat that takes over your body to tell you something isn't right. That is what I felt.

After spending my third grade school year with my dad, summer came and my mom drove the eight hundred miles to pick me up for a few weeks. Those weeks turned into the whole summer.

The last conversation we had with my dad was bizarre. He told us that I couldn't come home and he needed to figure some stuff out. I couldn't shake the sharp pain of worry that seeped into my stomach.

A few months went by with no further communication from my dad, until my mom received a call from the police department in his local town: "Ma'am, your ex-husband is wanted in regard to involvement in multiple murders. We can't seem to locate him. Have you been in communication with him? We have contacted your local police department and you will be under twenty-four hour surveillance until he is found. Ma'am, are you there?"

The three or four weeks that followed felt like a lifetime. Torturous for my nerves, the anger and confusion within me boiled: "How can this be my life? My dad, my hero, the father who loves me so much? Are you sure?"

Shocked. No one believed it; this man we loved, it was against everything that we had known about him. I never understood it. I still don't, to this day.

All I wanted was for this nightmare to go away, but it got worse. My friend's dad, a police officer, was informed of the situation. He told his daughter and on Monday, I felt the whispers of people—kids no longer able to be my friends, adults setting judgments.

The Shattering

My relationship with shame began here; a feeling that was handed to me with my dad's actions. Invisible labels were stamped on me: Criminal's Child, Trouble, Trailer Trash. Even some of our family looked the other way, not able to acknowledge my mom and I as silent victims.

No wonder I internalized the rejection, ostracized from the tribe, and chose invisibility.

When reality set in, it hit me like a ton of bricks. My heart was broken in a million pieces. No words can describe the deep pain of losing a parent. I cried in my mom's chest, thankful she was there. My mom made me feel nurtured, and she still does.

I was ten when my dad went away—and my heart went with him.

My dad was eventually sentenced with two life terms without the possibility of parole. For nearly two decades he worked the legal system to try and be

released. His story was covered by newspapers and books, setting in on my reality.

Scared Straight

When I was just a tween I became violent, taking on the anger of the injustice I felt in my life as a child of an incarcerated parent. I entered the justice system myself with multiple disorderly conduct, assault, and shoplifting infractions. Court ordered, I attended a Scared Straight day at a women's prison. Sitting in a cell, in the same environment my dad inhabited, felt cold. Listening to the women share their unfortunate stories shocked me. It worked—I was scared straight out of finding a lifetime with a man who was abusive. I was scared straight out of joining a gang. Hearing the locking of doors, and the keys clinking together at the waist of the guards was so loud, it echoed in my head for days after the visit. I was scared straight out of hearing those doors lock with me inside!

That experience showed me that I did not belong there and would not follow in the footsteps of my father.

I was scared straight out of being a statistic.

Change your perspective and life changes for you.

Numbing

My heart went numb. Journaling and hanging out in my room was my "safe space," where I could just *be*. Yet, me *being* was quite different from other girls my age. The trauma I had experienced thus far had exhausted my body. Chronic pain and fatigue became homeowners with my physical vessel.

Depression snuck into my whole being and I felt sick a lot. My mom took time off work and took me to doctor appointments to try to figure out my mystery pains and ailments. She did her best to create fun experiences; we danced in the living room a lot, and watched TV shows together in the evenings. My mom pushed me through school, often tucked me in at night, and read textbooks with me so I could get by in class. She still encourages me and is a big reason why I must heal our generational trauma.

Giving it all she had and working forty-plus hours with a constantly changing schedule, my strong mother struggled to keep our heads above water with the bills and maintenance on our single-wide mobile home. Busy and in a constant state of overwhelm, my mom illustrated how to survive. But she carried her own set of secrets, although she shared as much as her heart would permit.

Depression suppressed her emotions.

Generational depression cuts deep. Both struggling, my mom and I made a pact never to commit suicide. No matter what! We wouldn't do that to each other.

Together, mother and daughter pushed past deep-seated pain with hopes for a better day. That pact kept me alive a few times. Never fully making the attempt to leave this world, I couldn't bear the feeling of leaving my mom alone. Instead, I begged God to either, "Take me out or help me change my life!"

A Gift from God

The whispers from the trees. The autumn leaves spoke messages of the future. Driving home from class one breezy fall afternoon, I looked up into the sun peeking through the orange hues waving in the trees and asked, "When will I find my soulmate? Why am I so hard to love?"

I heard, "You will marry a man from Pueblo. You will move away, have children and then return to do final healing." It took my breath away.

What? How could this be? No, I can't marry a man from my hometown! That's not what I wanted; I had different plans for my life. All the journal entries of a lavish life spoke of something much bigger than my hometown could offer.

Eager to hear the voice again, I quieted my racing mind. It was familiar to me, yet not audible to others. This voice.

Will I have kids? Yes. My ovaries warmed.

Marriage? Yep. My heart skipped a beat.

Moving back to my hometown. Now the base of my spine felt a shooting pain. Nope, not safe. But I took a deep breath past the lump in my throat, drove the rest of the way home in silence, and crashed on the couch for a nap. Months later, my phone rang—a call to go in for a job that I had already quit. But they needed me because I was a good waitress and worked hard. They were going to have new servers and a big wedding. Reluctantly, I agreed to help them out because I needed the money.

Upon entering the kitchen, I saw him, smiling big.

Matthew: meaning "Gift of God."

We looked each other square in the eyes and, in that moment, we knew each other from other realms. Later, he asked where we recognized each other from—was it high school?

Secretly, I knew who he was from the moment I saw his smile when it all came visually rushing back to me. During my freshman year in high school, someone in the hallway yelled, "Nava, great game! You were in the paper." I remember him smiling. Smaller than some of the other guys, his style on point. He was shy; I liked shy boys.

I gave him a side smile and I said, "Let's get to work. We have a lot to do around here." Our tables were situated next to each other so we worked side-by-side all night. At the end of our shift, exhausted and relieved, Matthew smiled big and my heart went "pitter patter," something I didn't expect, or really want, at the time. I had plans to move to the big city of Denver after graduation, less than a year away. No time for boys, I was focused on school and bettering myself. He took the "friend approach" but that same shy guy in high school was now interested in me. Within a few months we became inseparable. We were a solid couple, both finishing college and partying hard together.

We had fun then and we still do now, seventeen years later, but without the alcohol and reckless behavior. We live for our two children and the family unit that God had envisioned for me.

Deep Love

Becoming a mother gave me the capacity to love unconditionally. My children's need for survival pushed me past exhaustion and into bliss. Nursing my babies taught my body a new form of determination as, with nipples raw, my baby lay peacefully on my breast. Becoming a mother was the biggest blessing I could have ever imagined in this life. The transformation that started within my body moved quickly to my heart, and it has never left.

My heart never stops constantly giving to my children. It illustrates my true nature, love, compassion, and worthiness to love my children. My son took my breath away the first time I met him, the umbilical cord wrapped around his neck, blue in the face.

My boy was quite often sick with respiratory issues; he brought my nurturing side out. Navigating my family through western and holistic medicine, I cuddled up with my son, doing everything I could to ease his distress.

Exploring nature with a two-year-old brought in a new fascination for life. The way the sprinklers created a rainbow over the green grass in the front lawn. My boy, in his stroller, was my running mate, encouraging me with a, "Go Mom, Go!" Little fist striking the air.

We sacrificed financially so, ultimately, I could spend my days with our son. That time with my son holds some of the best memories of our lives. Now, at just fourteen-years-old, he stands taller than me, although we share similar

mannerisms and mirror each other's annoyances. He and I are part of the same soul family, even brother and sister in another life, as told by a psychic and confirmed by my guides. My son is truly one of my greatest births to the world!

"All the people in our lives play an intricate role in the soul's evolution."

With the strong desire for another child, my husband and I felt frustrated as the months of "trying" turned into a few years. The disappointment took a toll on my body and emotional eating numbed the pain and loss. Searching for answers, my favorite place became a yoga mat as I moved my body through poses to release trauma and open my body to motherhood.

Little did I know we were being guided by our spirit baby, the soul we now know as our daughter. My husband and I were led to learn mantras and healing chants. Developing these practices eased our minds and raised our vibrations so we could welcome in a baby. The feeling was with me during a yoga teacher training; as if she introduced herself during a *savasana* and the feeling of being pregnant never left. On the way home, I picked up a pregnancy test—and it was positive.

The Mala Maker

The awakening in 2012 rushed into my life in all ways and with so many unanswered questions. Searching the night sky for clues. Dreams serving the purpose to move me through the ethers. ET guides activating my crystalline light body. I would wake up feeling different, lighter. Physical pain removed. My heart space open and somehow sore to the touch.

"I am a soul, not just this body. For it is the beautiful vessel that keeps me human."

Still carrying the wounds of childhood, I found a space in the back and unrolled my mat hoping nobody would notice me. *Hopefully, we won't do much yoga.* Although I loved yoga, somehow, it didn't alleviate my chronic back pain. The teacher led the class of *108 Sun Salutations*—remarkably, the devotions held up my body—as we dedicated each salutation to someone special in the world, somebody we deeply love.

For somebody who isn't accustomed to them, *108 Sun Salutations* is like going to military boot camp.

Finally—time for savasana; I collapsed to the floor, surrendering to the mat deeper than I ever had in my life. Exhausted, I could feel my muscles melting. Laying there, tears streamed down my cheeks in gratitude for what I had just accomplished.

The room was silent as we lay in our own sweat. Tapping into the collective heartbeat of the room, I could feel my people, my brothers and sisters of this planet. My heart gave out an electric current of love. To love all, seeing everyone in the room as me. One Love.

Each with a story no more or less important than another. All experiencing these human emotions. My purpose finally showing itself: Conscious Connected Conversations.

My lower back pulsing, I begged God/Gaia to take away the pain, "Please what can I do? How can I live a healthy, happy life and be a yoga teacher when I have this much back pain, please God help me figure this out."

Within a few breaths, I could feel something miraculous happening within my body. It was like Gaia/Mother Earth was rooting me down and pulling the pain out of my back. A true release.

My breath deepened, surrendering even more. Relieved, I asked, "Dear God, how can I repay you for this peace, this peace you bring upon me. Wow, what would this feel like to live a life without this pain?" The familiar loud voice declared, "Make Malas."

"Make Malas?" I said in my head, "No, no, that's not for me. I don't know anything about crystals. I can't make Malas." The voice said, "You asked, we answered, make Malas—it will heal your pain."

I came back to the room, wiggling my fingers and my toes, knowing that something had changed and my life would never be the same. When I approached my mentor and shared the experience that had just taken place, she smiled and, with a tilted head, confirmed that Spirit will ask us to do weird things but it's up to us to follow the path.

When we got home from the yoga retreat, I hyper-fixated on this mission of making Malas. A Mala is a 108 beads, knotted together with a mantra and used for meditation. At the time, I owned a couple of Malas and took them apart to learn how to make them again. My mentor and friend helped by leading me through the sacred process.

The hematite, cold at first, vibrated my hands so much that they started to shake. An electric shock riveted my body, introducing me to the real healing power of gemstones. It was then I started to download the meanings; the purpose and properties of all the gemstones started coming naturally. The gemstones talked to me, gravitating towards each other, signaling to me which gemstones paired well. Holding the completed hematite Mala that I made in my hands, a knowing took place. Something well beyond what I could ever imagine would be coming and placed within my life.

I couldn't stop thinking about Mala designs in my dreams while I slept, and throughout every day.

I became obsessed with making Malas, praying, and learning as much as I possibly could about Japa meditation and mantras. Making Malas for family and friends then became a business to handle the demand. It truly invigorated my spirit. Placing crystals on the body and doing chakra healing came naturally. Adding the crystals into my already spiritual essence amplified everything in its power. My life shifted very quickly, bringing in a new resilience.

A new intention, a new intuitive mind connected from Gaia Mother Earth to God, and all of my guides strong in tune with me, Amy—my body, my soul, my spirit, strong.

Dark Night of the Soul

The idea to create a conscious community was born. We sold our suburbia lifestyle for a new dream. Tapping into spirits and oracle cards, we found ourselves in the middle of nowhere at the base of a mountain range. There we were, alone yet not fully alone, with an eerie feeling of being in the middle of nowhere, yet feeling like we were being watched. Within a few weeks of arriving at our new spot on the map, shock hit me and the stress of moving tightened all the muscles in my body. One morning, I woke up unable to move my right arm and with striking pain up my neck and down to my fingers. This was something I never had felt before, and a feeling of doom clouded my vision. Snow was up to our knees and the temperatures were falling below double digits. We spent days without seeing people.

I sat in a stranger's house, in excruciating pain, once again falling deep into the darkness of depression. Worry and shooting pain kept me up at night. Desperate to escape, the tingling in my right arm left me with no strength. I couldn't even journal or map out a plan of change, like I had in the past.

I felt like a failure for taking my family on a journey into uncharted terrain to follow the whispers of spirit.

The physical pain consumed all my energy, leaving me with little to give. Self-care was no longer, as I found only energy to eat. The guilt ached in my hips as my body prevented me from experiencing life with my family. The daughter we yearned for, and worked so hard to be healthy for, was witnessing me fall apart. Sometimes all I could do was muster up enough energy to prepare my crew for hikes that I couldn't take, waiting to see what treasures and stories they would bring back from their outings.

Desiring deeply to be seen within the small community that we moved to be a part of, once again, I was invisible. Hiding in my pain.

The mountains towered over us and the aroma of juniper and pinon trees made our inhalations sweet. I made friends with a tree. Sitting under my tree, I read the last letter from my dad. Spirit delivered his goodbye letter to me the day his heart stopped beating. And my sweet, sturdy tree held me deep in connection with nature, allowing me to grieve the final human loss of my father, even allowing me to leave a spread of his ashes at its base.

The life we sought drove me into the darkest "night of the soul" that lasted almost four years. Nights spent on the bedroom floor, begging God to change my life or take me out of it! One ailment triggered another, and my health issues grew with each month before I could grasp what was going on with my body, let alone heal. Smothered in pain, I deeply felt the call to run, run far away from this place where my body and mind fell apart. Demanding that we move, or I die there.

"Making big moves to survive brings the most bravery."

The Calling of Home

The town I never wanted to return to, is where we call home, again. The hometown that both my husband and I grew up in, the place I lost my innocence, the place that never felt safe. Yet we moved our family of four back to where it all began, to be close to our family, to create a new life in an old town, after becoming a higher version of myself for this final stage of healing that was whispered through the trees all those years ago. This time driving past those trees, I am grateful to be home. Sturdy in my roots.

To become a stronger woman than when I left, I had to forgive myself. Forgive myself for all the pain endured that was self inflicted, and so much of it out of survival. I had to release the judgment for all behaviors that built shame in my cellular body. Much of this work was done through connecting deeply in heart and meeting all aspects of self with love and compassion.

Knowing deep in my soul that Love is my nature and I am sovereign.

The wise woman sits in Grace, Peace, and Power. Holding the wisdom of this world and other realms. A mystic before birth, she listened to the whispers of her spirit guides. Experiencing life from the energetic body, all senses heightened. The essence of the presence moving her from one vision and action to the next. Sweet surrender.

This life is built through the foundation of spirituality that I have come to water over time. I am watching this whole new awakening happen in the collective—and we're only just beginning.

Walk into the path of awakening, grounded and always guided by Spirit.

Invitation to Mantra Meditation

A mantra is a sacred sound, word, or phrase that is repeated, usually a minimum of 108 times. When recited in a meditative space, the sound vibrations echo to the universe, connecting with God Source Energy. Specific mantras can invoke different vibrations within our energy field. Using the voice to vibrate the body and aura is similar to dialing up someone on the phone. We can connect to our higher selves, deities, and God.

Aham Prema is a beautiful mantra that I have personally practiced throughout my life. This mantra connects with our heart and source, creating a perfect harmony of gentle healing.

>Aham Prema (*ah-hum pray-mah*) translates as "I Am Divine Love."
>Aham:"I am" Prema: "Love"

I invite you to take three full deep breaths in through your nose, exhale with a sigh, allow it to be audible.

Out loud say the mantra Aham Prema (ah-hum pray-mah). Take your time, feel it within your heart.

Repeat this mantra at least ten times. As you say the mantra, look up to the sky. Imagine your voice creating resonance in the heavens.

As the exercise completes, feel into your body again and notice the subtle differences in your energy field. You may be feeling more warmth in your heart, an expansion in your throat, and a smile on your face.

This meditation practice is simple to develop, yet offers incredible connection to the universe.

Traditionally, a mantra is practiced at minimum for forty days, and usually with a Mala. A Mala can enrich this mantra experience by offering a tool to help keep count of the mantra, and as a tactile tool for the body to use if meditation feels difficult. Plus the gemstones in the Mala will amplify your intention.

Aham Prema flows nicely off the tongue, so enjoy yourself with this sacred mantra. Allow it to move with you throughout the day, incorporate, and vibrate!

Blessings,

Amy

Perhaps you have felt the shame of a family member passed down to you. Maybe you too have internalized trauma and felt it permeate your body. In my chapter, I pose a few questions that may have brought up memories in your own life. I offer you space to reflect on those questions here. Feel into them—what comes up?

1. *When was a time you felt cloaked beneath invisibility while deeply desiring to be seen for who you truly are?*

..

..

..

..

..

..

..

..

..

2. *What do bottled-up emotions feel like in your body? Is there a specific place you hold tension—and why?*

..

..

..

..

3. Who in your family have you placed in the hero's light, only to be disappointed by them later?

A mother understands what a child does not say

Jewish Proverb

CHAPTER FOUR

Dear Daughter, Dear Self

Finding Self in the Unbecoming: How the Deep Call of Motherhood gave Rise to Learning to Mother Myself

This isn't a story of finality with a clearly defined resolution. Rather, this is a story of process, of becoming through unbecoming, of layer upon layer being peeled back. The lessons are far from over; there will always remain further excavation and understanding to deepen. But for this moment, it is enough.

I have traveled many miles in my journey, prompting me to transcend more deeply into my unbecoming. Facilitating the embodiment of healing, heart-led living, and coming home to myself. For myself, for my daughters, for the women who came before and will come after me.

What follows is an offering to validate my journey, and perhaps validate the journey you have been on too. Offerings to authenticate the duality of life. Offerings to normalize what it feels like to ride the ebb and flow. Offerings so that you may know you are not as lost as you feel. Offerings to encourage you to hold faith in knowing the "coming together" blooms via the "falling apart." Offerings to allow the remembering of your magic. Offerings to remind you that serving the external world well begins with nourishment of the internal. Offerings to serve as reminders to myself and my daughters. An ode to all that was, is, and will be.

> *I have arrived*
> *Into a place that transcends questioning*
> *Extending beyond the temptation of noise*
> *Unsusceptible to influence*
> *Exceeding validation and explanation*
> *Past the boundaries of pragmatics*
> *Rooted within primal instinct*
> *Like a thread pulling*
> *Ushering us into the currency of a calling*
> *In the absence of comprehension*
> *In the reverence of the unfolding*
> *Unaccompanied by the how and why*
> *Unconcerned with circumstance*
> *It defies it all*
>
> // Currency of a Calling

For as long as I can remember, I felt different. Housed within my body and interwoven in the fiber of my being is a deep-seated empathic and intuitive "knowingness." A knowingness that was shaped long before formulated memory and thought, and strategically placed within my DNA by God himself. An intrinsic tendency for knowing, sensing, and attuning to the world and energy around me. Of feeling my surroundings with intensity, depth, and sensitivity. Without consciously choosing, I have been a keeper and holder of the depths, both my own and others. Highly attuned to the emotional and energetic climate of my surroundings.

Prior to becoming a mother, this encoding felt more like a curse than a blessing. To be hyper-aware of the unspoken and spoken depths of humanity with such enormity has shaped me from a young age. My nervous system picked up on every subtle nuance and emotional undercurrent with precision. Environments, unexpressed emotions, sights, sounds, smells, caffeine, medications, transitions, change, and even the way clothing felt on my body; there was a strong sensitivity to everything and a constant stream of information to be processed. It felt exhausting. I attempted to navigate without the ease of guidance, validation, or wisdom around how to understand, process, and regulate it all. Without knowing what to do with it or where to put it, the energy inevitably stayed in my body. Life carried an overarching feeling of intensity, and as a result, it was difficult to feel safe. My internal nervous system felt like a live wire carrying a high voltage charge. All the noise and chaos created from that charge made it difficult to quiet and tune into my own frequency. It was almost impossible to turn down the sensations to find grounding and clarity amongst overwhelm and unease.

I was keenly aware that the way I processed the world was different. I experienced life as arduous and the feedback I received was often interpreted in a way that formed the belief that I was high maintenance, dramatic, difficult, and too sensitive. I somehow felt "wrong," as though something unnamed within was somehow not quite right. I questioned whether I was too much and not enough, all at the same time as I wondered why others did not seem impacted by life in the same way.

I longed to find an emotional haven: to feel safe, to be told that who I was was not wrong, to see the gift in my traits when I could not, and to be nurtured as I was. I wanted someone to help me make sense of all that I felt. To cope, I filtered my emotional barometer through my intellect and overanalysis, generating further confusion and contradiction within. I wanted to fit into a box that seemed more palatable and made logical sense to the world and to myself. I often found myself white-knuckling it through, with life feeling like an uncomfortable ride, much too wild and fast for my preference.

I see now the things I desired,
were denied to you first
I see now that within the experience of abandonment,
was the abandonment of yourself
I see now the criticism and shame projected,
were housed within your body long before me
I see now the sensation of tension,
was a response to your emotional unrest
I see now it did not start with me,
I see now it did not start with you
I see now

// I See

In my early teenage years and into adulthood, I began having encounter upon encounter with friends, acquaintances, and complete strangers. I cannot explain why, but they were drawn to me. Countless moments, random circumstances, and divinely-timed connection with those needing the deepest part of their soul witnessed, those who vulnerably shared their innermost corners of their heart with me. It was no surprise that personal growth and psychology were on my radar early on. And that is where my education naturally led—to credentials of an undergraduate degree in Addiction Counselling and a Masters of Arts in Counselling Psychology. Personally and professionally, I loved the world of personal growth and human nature; I thrived, and felt passionately about this field.

After spending many years pursuing and expanding upon my passion through education, internships, and employment, I entered motherhood. I was handed the most sacred mission of all when God gave me three little girls. Growing their souls within my body, delivering them earthside, and nurturing their being has been my most profound calling. This calling has led to a rewriting of all I thought I knew, a rewiring of every cell, an altering of every perspective I held.

Motherhood gifted me with the meeting of an edge. An edge that awoke an undeniable knowing that was always there, but was further magnified through maternal instinct. An edge met that delivered me into an eventual softening that allowed these knowings and instincts to lead. A heart expansion so large that I could no longer live trying to shapeshift into living life or mothering by rules that I knew did not work for me or my daughters, despite my efforts. A season that positioned me for releasing logic, trusting my heart, and falling deeper into the embodiment of a heart-led way of living, leading and nurturing myself and my daughters.

However, this edge came crashing in alongside a perfect storm and collided with my wiring as a sensitive person. A storm unleashed events in rapid fire that resulted in a complete upheaval of my nervous system, and delivered me straight into the arms of a dark night of the soul. The stories and pain points carried within my body came to a messy peak. Things that sat dormant came roaring to the forefront, ready to be shed. No longer did I have the space or willingness to store them.

> You are held, even if it is not known
> You are whole, even if it is not felt
> You are unbroken, even in the shattering
> You are complete, even in the undoing
> You are found, even in the feeling of lost
> You know the way, even though nothing makes sense
> There is no right, even in the feeling of it all being wrong
> There is only this invitation to receive the wisdom within this hard moment
> There is only this invitation to allow it all to be
> There is only this invitation for just this moment
>> Set free what appears to need fixing
>> Release what seems to need figuring out
>> Allow the noise being stirred in the mind
>> Let go of the impulse to do and control
>> Liberate yourself from the resistance of endless trying
> There just is
> In the denseness of the messy
> In the wave after wave of grief
> In the violent push/pull of resistance
> In the murkiness of discomfort
> In the temptation to grasp onto joy
> It all belongs
> Every part of this moment, this season, has a place
> In the feeling of being adrift, you are already your own anchor
>
> // Anchored Within

The storm began in the midst of the cold and flu season, three weeks after my second daughter arrived. What I anticipated as being a cold quickly turned into her tiny body laboring to get the oxygen it needed. Despite multiple trips to the local emergency room to have her assessed, we were turned away with dismissed concerns. My intuition continued to tell me something was not right and, considering the realities of where we lived, I grew more and more alarmed. Our remote rural area was not necessarily well-equipped to support a tiny infant. On our fourth trip into the emergency room, nurses

failed to complete a full evaluation on my daughter and the doctor was dismissive. I reached the end of my tolerance for being agreeable and refused to leave until a full and proper evaluation was done. My request was granted. Findings showed that my daughter was not fine at all, she had a serious case of Respiratory Syncytial Virus (RSV), a cold-like virus that impacts the lungs and respiratory tract. We were promptly loaded into an ambulance to be transported to the nearest city hospital, where my daughter could finally receive the support her body required.

The ambulance personnel were not familiar with providing support for a newborn baby and precious time ticked by as we sorted out how to safely transport her. Creatively, we strapped her car seat onto the stretcher and were finally en route. I held her hand the entire way, watchful of each breath. I could sense the anxiety within the ambulance personnel, as this tiny patient was out of their usual scope of practice. The ambulance raced its way through 200km of desolate landscape in the dark night, in a sense, serving as foreshadowing of what was in store for me—a desolate dark night of the soul. I watched as the flashing beacons atop the ambulance lit our way, willing a faster arrival to safety. For the next four days, I felt helpless as I alternated between being at my daughter's bedside and holding her amidst the tangle of cords connecting her to oxygen and intravenous therapy (IV). I was instructed not to breastfeed her, as it exerted too much of the energy she needed to conserve.

Internally, something had been set in motion. A feeling of not being safe had always existed for me, but it was manifesting in a new way—a fear of not being able to keep my children safe. Over the coming months, multiple events would compound upon one another to lock this fear firmly into place.

> *It hurts less when we allow it in*
> *Allow it to tear us apart*
> *Spontaneously erupt and combust*
> *Consuming it all*
> *Ripping us open*
> *Exposing and removing*
> *All that was never meant to stay*
>
> *Lifted by the current*
> *Swept into the force of life*
> *An essence of something greater*
> *Lose sight of the shore*
> *Be engulfed by the burn down*
> *Allow a greater intelligence in*
> *To shape shift us*

To course correct us
To grow us
To expand us

// Depths of Expansion

Soon following, while awake in the night rocking my restless baby, I smelled it. Smoke. Seemingly coming through the furnace vents. En route to wake my husband to investigate, the sound of fire alarms pierced the air and beat me to it. We discovered the source of the fire in the furnace room, prompting me to quickly gather my sleeping children from their beds and carry them out into the coolness of the night. We would come to find out that our water was the culprit of the fire. *How does that even happen?* Our well water had a substantial amount of methane gas within its composition. As our filtration system ran a cleaning cycle, a buildup of this gas ignited and caught fire. It was not safe to reside in our home until we got the problem sorted. We were told to leave immediately, and later learned that these circumstances could have resulted in a much larger and more dangerous explosion. We were lucky, however the possibility of what could have been lingered on and shook me more deeply than the actual event that unfolded.

In the weeks following, the drought in our area led to many grass fires. It felt like having salt rubbed into my still-fresh wound. But the hits were not done. To round off this furious storm of events, my daughter began displaying allergic reactions to nearly all foods we were exposing her to, and a hunch revealed toxic black mold spores hiding in our home.

I had been skillful in work ethic, in the flavor of using intellect and mental stamina to push my body and mind further and faster. However, this skill ceased to serve in this season of my life and, instead, exacerbated my symptoms. I was severely sleep deprived, experiencing panic attacks, anxiety, flashbacks, and symptoms of trauma.

The events I experienced had convinced my body and nervous system that nothing was safe. If water could cause explosions and house fires, everything felt dangerous. If a simple cold virus could cause respiratory distress, ambulance rides, and hospital stays, nothing was safe. If my home could unknowingly house toxicity within the air, I must remain hypervigilant in anticipating and protecting against danger. I vacillated between fight, flight, and freeze.

Let it
And then scream and rage
Let it

And then resist and fight
Let it
And then weep and wither
Let it
And then howl and wail
Let it
And then spit fire
Let it
And then fall apart
Let it
Then let it again
Until suddenly it has softened
Until suddenly it is no longer
Until suddenly you are free

// The Invitation

All the while, I held high expectations for myself as a mother as I tried to navigate all that I was moving through. Aggravated by the reality of living in a remote rural area, I felt severely under supported, poorly resourced, and alone in my experience. Convinced that I was failing my daughters, I went to bed every night with the intention of trying harder and being more the following day. But my body did not care about my intentions and attempts to do and be more. At some point, my body said "enough" and I began to pivot. I redirected my work ethic; instead of continuing to push to be and do more, I began to champion for myself. Instead of martyring myself and being all-sacrificing, as the archetype of mother often says we should, I began to see the importance of nurturing myself alongside my daughters.

During this time I pursued many methods and began to recognize that I could not analyze or think my way into healing, or into understanding my experience of life. I sought more than just the bandaid, "quick fix" theories that did not leave lasting impact. Desiring beyond the surface level, neatly packaged, and intellect-based approaches, I tirelessly searched for humans who knew, who had been in and climbed their way out of trenches. Who spoke in a language of heart, soul, and the sacredness of human experience. Who valued the concept of reconnection into answers and wisdom within. I knew what I wanted and needed, and it required profound tenacity to find. But I was hungry. Hungry for healing, and on a mission for learning to embody the wisdom and skills for holding and honoring my experiences, duality, and depth, so I could also hold the experiences, duality, and depth of each of my three beautiful daughters.

She works tirelessly using her body to weave
The emotion holder
The anticipator
The magic maker
The memory keeper
The hearth and haven
The gatekeeper
The nurturer
The healer
The holder of hearts
To the Mama
I see you

// Heartbeat of the Home

Simultaneously, a deep and steadfast conviction arose. I was ablaze with intentionally being and creating a haven for my daughters to learn the very things this season was teaching me as a woman and as their mother. To be proficient in understanding the language of our heart and to follow the lead of our deeper knowing. To learn to use our intrinsic guidance and signposts to navigate this world, rather than making decisions through external means. To learn how to be warriors for our own heart and spirit, and be full expressions of ourselves. Our journeys were symbolically parallel in many ways. As I birthed my daughters, I was also born. As I mothered my three beautiful girls, I learned to mother myself. As I gave my daughters grace in their growth and unfolding, I learned the same. While I witnessed their purest expression of themselves as uncensored souls, I began to uncover my own.

As I developed literacy for understanding the language of my heart, I taught them about their own. As I leaned into trusting and surrendering into my internal compass and knowing, I taught them how to trust themselves to do the same.

As I reclaimed my voice, I taught them about the power of theirs. As I excavated generational patterns, I instilled new ways of being into our lineage. As I quieted the noise to hear the wisdom, I taught them the importance of stillness and being vs only doing. As I exchanged external things that were never capable of holding me, I taught them the importance of investing in themselves. As I stood tall in my convictions, I encouraged them to explore and stand in theirs.

As I have reconnected with self, heart, body, and life force, I am teaching them what connection feels like. Mothering my daughters in the way I have been deeply called to, has given rise to learning to mother myself in all these same

ways, alongside them. With motherhood leading the way, it has been a journey of coming back into the wisdom within myself.

> *She finds it,*
> *Nearly every time*
> *In the crashing waves, or the gentle lapping*
> *In feet naked and bare pressed against the sand*
> *In the morning energy and early sunlight*
> *In the heat blazing against exposed skin*
> *In the way she feels half naked and undone*
> *In the way the cold water engulfs her body*
> *In the way she feels capacity for play and exploration*
> *In the way her essence naturally emerges, even after drought*
> *In witnessing her children run wild and unrestrained*
> *In the way her heart feels unchained and unburdened*
> *In the way her spirit shifts, ceasing to feel broken*
> *In the way she can connect; with self, them, God*
> *In the way scarcity is replaced with a sense of being fed*
> *In the way her soul suddenly feels spacious enough to breath, again*
> *In the way her body sighs in relief*
> *In the way her mind quiets and stills*
> *In the way the intensity of the longing and starvation feels quenched and quiets*
> *Like a baby who suckles to sleep against a mothers breast*
> *Safe, close, connected, content*
> *Drifting off*
> *How could it be wrong?*
> *Like a thunderous whisper*
> *How much more clear could the message speak itself?*
> *Now she only need listen*
> *To take a single next step*
> *To let her truth guide her into her own existence*
> *There is nothing to find, it was there all along*

> // Heart Personified

There will likely always be a pressure to be and do more. Always be perceived shortcomings in how I am fulfilling the sacred role I have been handed as their mother. But I have come to believe that what our daughters need least in life is a perfect mother. Striving for and modeling perfection, hiding our flaws, vulnerabilities, and the spectrum of emotions we move through that make us human, is a disservice. Whatever it is that we embody will permeate into our daughters, whether that is intentional or unconscious. Demanding perfection within ourselves diffuses outwards. Power lies within our imperfection,

vulnerability, mistakes, and our ability to accept responsibility and make amends. There is wisdom in admitting we have found ourselves down the wrong path, course-correcting our trajectory, and leading through the lens of a growth orientation. I believe the single greatest impact we can have as mothers lies in the quality of our connection—with ourselves and with them. The quality and capacity for this connection lies in our ability and perseverance in showing up to care for ourselves. How we nurture them, will inevitably be a reflection of how well we have nurtured ourselves. At the end of the day, the way our children feel and sense us, and the way our presence feels within them when we are near, is what they will carry with them the rest of their lives.

To my Daughters,

There will inevitably be a day when you realize I have let you down. Where I have not shown up for you in the way you needed or hoped, left you feeling let down, angry, and hurt. Despite all this, I hope I have provided you with a warm, safe, and stable haven. Where you have felt accepted for every part of who you are, and every emotion that has moved through you. That I have felt like home. That I have been a place where you could dissolve, and have your heart held and bolstered. A place where you have learned from the beginning to hear and value your heart, its language and guidance. A place where you have not felt the need to mold yourself into impossible shapes and boxes. A place where your voice mattered, was valued, and heard. A place where you could be your fullest expression, no matter how that looked, or how messy and undone. A place where you were loved for it through and through. A place where you could show your vulnerability, speak from the heart, voice your truth, be loud, be quiet, be bold, be timid, be emotional, be worried, be scared, be sad, be joyous, be rambunctious, be celebratory in your wins and triumphs. A place where you could ride the ebbs and flows of life out loud and unafraid.

When the world is loud, confusing, and chaotic, I hope I have shown you that you will find what you need in the stillness of your own heart. I hope you know, too, that there are no wrong answers. Only lessons and opportunities for deeper knowing of self. You are on your own timeline and your own journey. I hope that I have embodied these things for you, so that you know how to provide them for yourself, with the ease of an old familiar road.

With all my love,

Your Mama

Reconnection to the Heart

The mental load and expectations in motherhood can be significant, and we may hold ourselves to impossibly high standards. While traversing the depths and holding it all, we may move ourselves to last in line, losing our center, and wondering who we are. Everywhere we turn, we are being sold on the idea that success is held hostage within how quickly, or if, we can "bounce back." In multiple ways, we attempt to return to the previous version of who we once were. But who we once were no longer exists. If we allow it, motherhood is an opportunity that can lead to our expansion, evolution, growth, and unfolding. It is not possible to fit ourselves into the rudimentary version of who we once were. It would be a disservice to ourselves, and our children, if we successfully erased all that came to be by reverting to our former selves through a true bounce back.

And so, our work is to lean into this new version of our becoming. To learn the language of our heart and intuition. To open to self discovery. To uncover the unique ways our heart and soul desires to be nurtured and fed, rather than taking a one size fits all approach to caring for ourselves. The simple activities I have included will help explore just that; I come back to them time and time again.

Activity One: Create a Mood Board

Utilizing Pinterest, create a mood board with images that speak to you in some way. Look at the mood board and images you chose and consider the following questions:

What feeling does the specific images/overall board elicit?

Why are you drawn to the photos?

What themes do you notice? Are there specific colors, feelings, styles of images, subjects photographed, etc?

What do you make of these themes, and is there a deeper meaning attached? What does it reveal about your heart?

How can the themes and feelings that were uncovered be woven into your life, and translate into specific ways to nurture, nourish and feed yourself? The goal is to start small, and not create added pressure.

Activity Two: Free Writing

Throughout my life, writing has been a way for me to express the way I experience life with depth and sensitivity, and therefore, process it. For me, words and writing are very spiritual, serving as a direct connection to God and my heart. Through this form, emotion can be transformed into art, experiences can be witnessed, and the sacredness of what we have been through can be honored and transmuted into beauty. Through the act of writing, we can bypass the concrete logical mind, into the abstract, where emotions and wisdom are held, and we can access and uncover deeper parts of self. This is an invitation to begin experimenting with writing and words.

Start by writing the following prompts on your page and begin free writing. This form of writing can be anything you want it to be, there are no rules. We are mainly interested in putting words to your thoughts as they flow in. Allow your writing to jump around and go wherever it wants, unrestrained. Do not be concerned with proper grammar or sentences, or whether or not your writing makes sense. Set a specific amount of time, and write continuously. The further you get into this, the more your mind will settle and your heart will reveal itself.

Prompts:

4. What does my heart want me to know?

5. What is my heart feeling, and what emotion is it holding?

6. What does my heart need/desire in this moment?
 How can I best provide that?

Being a candle is not easy, in order to give light , one must burn first
RUMI

CHAPTER FIVE

Walking My Inner Child Home

What is normal? I never really felt normal, even as a child, but why did I feel different? It made sense when I heard this on a podcast not that long ago: "Normal is a mask, and normal is programmed." And at the age of sixty-one, I'm finally and slowly accepting myself for who I have been and who I am becoming. *Are you ready to take off your mask and become who you are meant to be? Free to be You, All Of It?*

My chapter in this book is about my inner child being subjected to years of inappropriate sexual advances, having emotionally unavailable parents, feelings of violation to every part of me, and being very disconnected from my body, so I learned not to feel what was, simply in order to survive.

When I saw myself as a thirty-year-old through the eyes of my four-year-old daughter, as she sat on her granddad's knees, my subconscious mind opened like floodgates as memories came rushing in like a whirlwind; memories I previously locked away, the key thrown into a deep, dark cave. It was then that my journey into self-discovery began—of who I was and what has happened inside me. I crawled the path of forgiveness slowly, painfully, and often lonely, peeling away layers while holding compassion for myself, my parents, and my perpetrators. I can honestly say that I now have the most loving and caring relationship with myself, from deep diving within.

I grew up in Switzerland with four sisters; my dad wanted a boy so badly, but when I came along at number three, according to my mum he didn't show much excitement when he found out that he had a healthy, beautiful girl. As babies we don't understand words, but we do understand feelings, so in my subconscious mind I created a story that I wasn't loveable because I was "just another girl." I don't have any memories of the first five years of my life. However, we were a typical family living in a village where the Catholic faith was very strongly practiced—going to church every Sunday, behaving as a good little girl should without questioning anything, let alone showing emotions. Often when something upset me and I felt the tears well up, I was told with a stern voice, "I will give you something to cry about, so pull yourself together and get on with it." Being programmed early in my life, I did my best to blend in so I wouldn't stand out or cause any trouble. Deep within something would stir, my soul whispering, but I didn't know how to respond let alone how to be expressive.

My parents were emotionally, physically, and mentally unavailable to me and my sisters in all of our younger years, which left me broken, confused, sad,

unheard, and totally misunderstood. "What is wrong with me?" I would often ask myself.

When I was about six-years-old, a male friend visited with my dad. And when I walked past, the man picked me up and lifted me high up on his shoulders. Because I had never experienced anything like that, I felt terrified and started to scream and kick out of fear as he put me down. I ran to my Mum, upset and craving comfort. Instead, I was scolded and reprimanded for my so-called "bad" behavior. Confused to say the least, there was an instant shutdown because that six-year-old could not understand what she did wrong. Slowly locking my true nature away, I totally numbed myself so I didn't have to feel anything because I had no idea how to go through this process.

Then around twelve-years-of-age, I was hanging out with a few girls in the playground before school. They were talking about boys and one girl mentioned the word "penis." I asked what that word meant (because I had never heard of it) which then, of course, stirred up quite a whirlwind with laughing, mocking, and fingers pointing at me. I prayed for the ground to open up and swallow me right there and then, so I wouldn't have to feel all the feelings that arose. I became the laughingstock for quite a while after that. My whole body felt numb and heavy, my confusion about life and how to deal with it caused me to shut down even more, and I closed off my heart, which felt easier than experiencing all that I was trying to express. School became a place where I didn't feel safe, happy, or understood, so I simply went through the motions like a puppet. My puberty was also very slow, and at the age of fifteen, I had very small breasts. One of my uncles used to call me, "flat-chested like a boy," which gave me more evidence that there must be something wrong with me because I was not like all the other girls my age.

Another frightening experience that left deep scars happened at the age of thirteen, as I rode my push bike home from school along a creek with fields on either side and no houses nearby. Suddenly, out of nowhere, a man riding a moped appeared behind me, and as he rode past, he kept turning around and looking at me. My heart started to race again as fear crept up within me. I had this feeling that something was not right and I didn't feel safe.

He stopped about two hundred meters ahead of me on top of a hill and I stopped below the hill looking up towards where he waited. There were a couple of different paths I could take, so I was trying to work out which one would be the safest for me. The main road seemed the best option in the hope that there might be cars on that road so I could attract attention if I needed help. With my heart pounding in my chest and my legs pedaling as fast as they could, I made it up to the main road. Sure enough, I saw him coming from the opposite side but my guardian angels sent me an old man riding his push bike at a snail's pace in the same direction I was going. So I adjusted my speed right down to his, allowing the man on the moped to drive past. He

turned around and started to follow me; I could hear the engine getting closer and my heart pounding louder but after a while he gave up and took off, and with my whole body shaking, I made it home safely.

From here on I have a complete blank—no memory whatsoever. Did I tell my parents? Probably not, because there was no point in asking for support or guidance as both were not available. I was always left to my own devices and I had no idea how to deal with this situation. Even my older sisters and I never really communicated about this. I guess I simply didn't know how to because I didn't have any role models to learn from. It was always easier to shut down and numb everything out so I didn't have to feel what my body was trying to tell me. I was left to deal with that horrible experience with no guidance, only to cycle the same five-kilometer route the next day, as if nothing happened.

Reliving this memory for the first time as I put it down on paper, I shudder with sadness and tears run down my face while I sit and hold my confused inner thirteen-year-old in my arms, telling her that she's safe now, and I'm here for her, always. The fear of men, me not liking who I was in this girl-body, and often daydreaming about what it would be like to be a boy, had me disassociating from myself and unconsciously going into my day-to-day activities, school, chores, and homework.

When I was about fourteen-years-old, my mum, two siblings, and one of my perpetrators went hiking in the Swiss mountains, staying overnight in a hut. I will not write here what unfolded that night but I remember everything now. In that instant, I completely shut down and "left the building," (my body). With no idea how to process that experience, I buried it into my subconscious mind. The next morning that memory was gone, tucked away deeply and safely so I didn't have to feel it.

For many years growing up, I remember shaking my head from side to side when I went to bed, perhaps in order to get these traumas out of my body. My legs also often felt so itchy that I would scratch them to the point of causing deep bleeding wounds; the scars still show to this day. All signs from my body screaming at me but, without any nurturing guidance, I had no idea how to process any of my emotions.

When I got my first period well after my sixteenth birthday, I was left to my own devices once again because I had no one to ask or talk to about what was happening to me. First, I thought I was dying with countless trapped emotions, so many unresolved traumas, and many unanswered questions.

I was subjected to years of inappropriate sexual advances by three separate men, which lasted up to the age of twenty. My naivety and vulnerability were certainly taken advantage of, and I become quite emotional as I look back at the twenty-year-old version of me in this now sixty-one-year-old body. It makes me feel sad to recognize that I never said anything—even though I

tried, it was to no avail! One incident that felt very scary in my whole body, left me deeply wounded and filled with fear, but I don't feel it's necessarily helpful for you, my reader, to go into any details here.

Riding my push bike home, I left my workplace early that day as I feared for my safety. I told my parents what had happened, shaking like a leaf, but without receiving any form of comfort or reassurance. All I wanted to do was to cry but that door had been shut years prior, as this was not something we were allowed to show freely. Emotions with deep scars had been suppressed, yet again, and I still hear my mom's voice echoing as all she said was, "I could spit that man in his face." My dad never said a word, his head was hanging low as, no doubt, he was carrying his own share of unresolved traumas so he was not capable of holding space for me either. That was the end of that conversation, and nothing more was said or done. Confused, broken, and disconnected from my body and my spirit, I kept going through the motions of getting through my apprenticeship with good grades.

In order to survive, I programmed myself not to feel too deeply, never reaching full emotional competence.

We experience life through our bodies, so if we are not able to articulate our life's experiences, our bodies speak what our minds and mouths cannot.

I feel that I have always been protected all of my life. Even in my teenage years I never did any drugs or drank alcohol. I had a deep inner knowing to keep my mind alert even though I felt totally disconnected from myself; something was holding me. At one point around the age of eighteen, I felt so violated and ashamed of being a woman that I started to hate my body. Hate is a strong word that I don't like to use, so with the power of my mind, although unconsciously, I stopped my period for about six months. Thoughts also arose about becoming a nun so I wouldn't have to be in the presence of men. (I am glad I didn't follow that path.) According to my mom, men were "all bad," and one day she told me to have nothing to do with them. I guess she didn't have the capacity for any real conversations with me; no doubt she never had any support from her parents either, so the cycle continued.

How could I love myself, when I never had any role models in my formative years? I could only do what I knew, and so, the template was set. My boundaries were not so much violated as simply not constructed in the first place. My parents couldn't help or teach me to develop healthy boundaries because they were also not able to do so in their own formative years. I never knew how to love myself, so my body shaming was huge; I hid her under big, loose clothes so I wouldn't be seen. Over a period of two years, I unconsciously put on over fifteen kilograms as a protective mechanism in order to look ugly, in the hope that no man would want anything to do with me.

When I turned twenty-one, I had the opportunity to go to Canada for a few months, and it was there that I met a nice young man from New Zealand. But every time he touched me, I would freak out and jump—my whole nervous system was traumatized. When I moved to New Zealand the following year, I thought all my problems stayed behind which, of course, was an illusion, but at the time I didn't realize it. We got married and, yes, I was very happy for a long time while I had these walls built around me. To me, sex felt more like a chore or something that a wife had to provide; with my deep traumas and numbing of myself, I simply left my body as I went through the motions without feeling anything and not enjoying sex at all. Again, I didn't have the capacity to talk about any of this. I thought this was the way I was, not realizing that I had deeply buried all those emotions so I wouldn't have to feel them.

Without even trying, the extra weight I had put on started to fall off easily, and I became quite skinny and attractive, yet deep down I still hated my body and my mind often complained about something.

Going back to that day when I was thirty-years-old: my subconscious mind finally opened up and allowed me to see what I had hidden for so long. My four-year-old daughter was sitting on her grandad's knees while we were having a simple conversation and, as I was looking at my girl, something hit me like a lightning bolt. The floodgates opened, allowing me to see visions of my younger self and memories started to flood through every cell of my body. I had no idea what was happening to me. The lioness in me fired up and I just knew that I had to protect my girl. Waves of deep emotions engulfed my whole body as I got up. Grabbing her from his knees, I ran into our bedroom, curled up in a fetal position and cried, screaming while clutching onto her. She looked quite confused but stayed with me in my arms for a long time. My husband walked in—with no idea what had just happened, he couldn't offer me any support or hold space for me because he simply didn't know how. He thought I had lost my mind, and I thought the same as I tried to make sense of it all.

That's when my deep inner journey began. By allowing whatever needed to come through and making space for it in that moment, the lioness in me roared and screamed, "NO MORE!" I knew there and then that I was going to break that chain of sexual interference because it had to stop. From then on, I became very open with my daughter, explaining to her that she was in charge of her own body and could set healthy boundaries about how to stay safe, but without raising a fear within her that she couldn't trust any men. I reassured her that she could come to me at any time if she had any concerns or didn't feel safe. Over the next few years whenever an awkward situation arose, I would gently guide her to stand in her own power and remind her that she was in charge of her own body and could say no at any time. My son was four years younger, so when he got a little bit older, I had the same open

conversations with him. When my daughter was around seven-years-old and the conversation came up again, I will never forget her answer, as out of a babe's mouth came, "Don't worry Mum, I would kick him in the knackers."

When memories resurfaced at various times, I had no idea how to process them without feeling that I was losing my mind, or that I was going crazy, so I had counseling sessions which helped me to work through so much. One exercise I was asked to do was to write a letter to each man, even if I wasn't planning to send it. But I started writing and sending letters to one man in particular because I wanted him to know that I remembered, although I tried to come from a space of understanding and compassion. Yes, I felt angry, violated, and betrayed but, without going into too many details here, after some correspondence we agreed to meet up. So I took a trip back to my home country to find some answers and, hopefully, feel some release of my many stored emotions. Although I didn't receive the response I had been praying for from my parents, instead of allowing anger, resentment, and guilt to take over, after doing a few powerful meditations where I saw my parents as little innocent babies, I decided to simply let it go.

My perpetrator was in hospital because he was dying of cancer. As I stood in front of the door that led to his room, I closed my eyes, and with a racing heart, said a prayer asking for strength and guidance, and allowing me to be a vessel of light. Opening the door with my heart in my throat, I walked over to his bed, knelt down beside him, embraced him deeply and both of us fell into profound and deep tears. We shook and sobbed and no words were needed until I finally broke the silence; through all my tears, I simply said, "I set you free and I also set myself free, I forgive myself and I also forgive you." His response is still deeply imprinted in my heart, "You have no idea what this means to me, I am truly sorry for what I did to you but I can die in peace now. Thank you." Nothing more needed to be said; all the talking and asking questions wouldn't have made any more difference and I didn't need any clarity of why, how, and what—I simply let it go. As I write this, I feel his presence all around me, I feel him in the breeze, I hear him in the birds, I feel him in the warmth of the sun and I hear him in the trees.

Of course, I'm not making excuses and saying what happened to me is okay, but it happened and I fully acknowledge it. At any given moment, I get to choose how I want to respond. It is not what happened to me but what happened inside of me. What happened to me was not my fault, but the healing is my responsibility. Now I choose to come from love. I feel no more anger as I write this—my heart is filled with compassion and space as best as my humaneness can grasp this. I've let go of all three men and anything they have done to me, and I choose to love this beautiful body of mine. She is strong, powerful, and resilient; my light is shining brightly. Hopefully, my dear reader, you can also choose to learn by trusting in your inner power and strength. Together, we can move forward and teach our children,

grandchildren, and their children to perhaps make different choices. Most importantly, it's okay to speak up, and it's definitely okay to say no.

Yes, I've often felt misunderstood, often not even understanding myself as I wondered why I was the way I was. But something was gently trying to show me why my soul chose to come into this particular body, to this family, and for every challenge lived.

Why did I choose all of these experiences as a part of this grand plan? Was it so I can write this chapter now and you get to read my story?

You, my reader, may have experienced something similar yet very different and unique to you. We are all deeply connected via this fine thread that binds us all together. What I now know, and have learnt as I sit here writing these words, is that we all simply have the desire to be heard, to be seen, and to be understood. Everything is perfect just the way it is right now. This may sound a bit hard to grasp, but if you allow yourself to sit quietly by yourself for a few minutes every day, and simply listen, feel, and observe, it is there in that beautiful space that you realize that it's all perfect and that the part of you that is the seer, the observer, is already free.

For me, it is all about letting go. Letting go of judgments and deeply ingrained beliefs that are way outdated and don't serve me anymore. Programs and paradigms are being deleted, and traumas are being breathed out of my body, mainly through practicing yoga. In Yin yoga with long-held postures surrendering into the sweet abyss, I can find myself. Initially, my mind often screamed at me because it felt so uncomfortable. Yet it was, and still is, simply surrendering into a particular posture where I meet my sweet inner child, so we can hold each other tight with tears of sadness that turn into tears of gratitude after a while, with nothing to forgive. Forgiving actually means to give to yourself; it is a letting go. The sweet release and surrender are here and in those still moments, my soul gently whispers, "You got this, girl."

For decades I didn't feel happy and at peace with my body, often finding something to complain about. My legs were too fat, my stomach too big, or my face too round, (which was a belief I adopted as a youngster when one of my uncles told me that I had a "full moon face"). I would allow my mind to bully my beautiful body—how cruelly I spoke about her.

Today I am very grateful for this body; she is my temple, and I feel so comfortable looking at myself naked in the mirror. I stopped coloring my hair about ten years ago when I realized what I was doing to her. Trusting my body's own natural rhythms and cycles of ebb and flow. My body is truly

incredible in how she got me to this stage of my life, and every day I allow myself to fall deeper and deeper in love with her—no makeup, fillers or cover-ups—completely in her raw, authentic, expression of self.

Wrinkles are such a beautiful feature that no one has to be ashamed of. Yet we live in a society where so much gets put on us through programming and conditioning. No more body shaming, no more hiding, and no more running away from ourselves. Whatever you are covering up and hiding on the outside is also deeply affecting you in your inner world. You're hiding your beautiful light and dimming your own true essence to flourish. Looking good on the outside while the inside is screaming at you to take down the barriers. Break the chains so you can be authentically you, in full beauty and glory, free from all your past hurts and pains. Healing starts from deep within where all your unprocessed emotions lay silently, waiting to be felt and then released through your body.

Allow yourself to "sit" in silence in all your vulnerability and rawness. Bring all your scars, wrinkles, lumps, and bumps to be seen. Freedom, oh sweet freedom—breathe in deeply. Savor that essence that is life, bathe in it, and breathe out anything that is no longer serving you. Then keep on doing that. Coming home to yourself, feeling safe and grounded. All my past experiences have brought me to this moment. Lessons I have learnt; mis-takes transformed with the beautiful weaving of magical now-moments unfolded breath by breath. Let's embrace and deeply honor our sacred vessel that carries us wherever we are going. Are you listening to her whispering to you? What is she asking of you right now as you read this?

Close your eyes with your hands on your heart, go within, and gently listen and connect with her. Which younger version of you is speaking to you in this moment? Where do you feel it in your body? Breathe into that space, perhaps even allowing your body to move. This is certainly not something that I have ever been taught at home or in any school; for decades I felt so disconnected from my own body, until my soul tapped so loudly that I could not ignore her any longer. Slowly, I started to peel away the layers, deep protective layers with chains around my heart that blocked me from my own authenticity. There has been lots of crying, screaming, shaking, and dancing while I surrendered to her more and more, diving deeper and deeper into my soul's essence, allowing that flame to slowly ignite once again. Breathing love into her so it could burn brighter and brighter.

Carl Jung said, "We don't really heal anything, we simply let it go." We don't do the healing; the body does all that by itself if we let go. Now I say to my body, "Thank you beautiful body for putting up with me."

Those memories will always be with me but they don't affect me anymore. Today I see them as beautiful lessons learnt. Issues get stored in our tissues

and emotions are simply energy in motion, but if we don't allow those emotions to move through then they stay stuck in the body, eventually causing physical tension. Every breath has a letting go phase. Inhale, then try and hold onto that breath. You can hold it for some time, but after a while, you simply have to let it go. It's how nature intended it to be. So, are we going to accumulate all this stuff, be it material, emotional, mental, physical, or spiritual? How much can we hold onto until something gives way? One day we all take that last final breath, which will be the ultimate letting go of everything. Until then, I choose to love unconditionally, first of all myself, then all my family, my friends, my community, then humanity—simply choosing to come from love. Opening up my heart, freeing myself from any burdens I may still carry.

I honor you. I see you; I feel you; I hold you; I love you. As I look back on my life as I've been writing my story, I am grateful for all the experiences I had because the woman standing here today was created through these experiences. I can look at my story and my traumas, and remember some of them clearly, but they don't affect me any longer. There are never any mistakes, even though I was not in touch with my body for decades and shut down emotionally.

Looking back now at the way I raised my kids, if there was a way to turn back the clock, I would certainly do a lot of things differently. But again, I did the best that I could; in any moment, I did the best I knew how to with the consciousness I had. I did what I knew and what I had learnt, what had been passed down to me, because my emotions were so shut down. Today I know differently. Today I choose to listen to my body. Turning inwards, asking, listening. My dear reader, ask your body; it knows and it keeps the score. Sometimes the body actually says no. Listen to that small, still, inner voice and become grateful for all your experiences because they made you who you are today. Perhaps my story can inspire you to finally speak up, to also make a stand, and as I pass my torch onto you, give yourself permission to use that flame before you also pass it on to someone else. Together, we can create an amazing ripple effect by breaking those taboo chains, standing tall as we show up in this beautiful world, knowing that our daughters and their daughters will not have to go through what we did.

I am forever grateful for this journey. Taking my inner child by the hand and walking her home. Home is not a place; home is right here in our hearts and in our bodies. Welcome home.

Thank you, my dear reader. With all my love, I wish you all the best as you walk your path of healing, aka, letting go.

I invite you to use the following blank pages to journal on the following questions:

1. What relationship do you have right now with your body? What fears come up for you, and what thoughts arise?

2. Bring opposite hands to opposite shoulders and hug yourself. Sit with yourself and just feel what comes up for you. How does your body respond? Your Heart? Your Soul?

3. Allow your body to go into a yoga child's pose; curl up there, be still, and listen deeply within. What do you feel and where do you feel it in your body? Trust any emotions that are willing to be released, as they are the gateway to your soul.

4. What thought patterns are running on automatic pilot in your mind daily? Are they positive or negative? Take some time to check in.

5. Are you running from your true feelings, and are you hiding from your true self?

I can't think of any better representation of beauty than someone who is unafraid of being herself.

Emma Stone

CHAPTER SIX

Your Worth Is Not Defined By The Weight Of Your Body

I laid there, tears streaming down my cheeks, dropping one by one onto the pillow case. It was the first night in days, possibly weeks, that he was home during the night. He lay there, his back to mine, sleeping so soundly he couldn't feel the shaking of my body or hear the muffled cries holding tears of deep sadness. The silence was so loud.

This sent a rush of pain through my body, reminding me of all the times this happened to me before. There I lay, silent screams in my mind, begging to be fixed and worthy. To be seen. To be heard. To be loved in that way. I was hurting, confused, and so angry. What was wrong with me? Why was I not worth the truth, respect, kindness, love, commitment, and loyalty?

Staring at the ceiling, my eyelids feeling heavy, the tears starting to slow, I fell asleep.

I was not a stranger to this feeling. Nearly every romantic relationship up to this point, had ended up in infidelity, verbal, mental, and/or emotional abuse. Oftentimes, all of the above. In those moments, I truly felt like I was the problem, I was the broken one, that I deserved it because of who I was or what I lacked. Constant whispers in my mind of all of me that needed to be fixed.

Oh to Be a Kid Again

I had a wonderful childhood and home life. My parents were high school sweethearts, and while they were no stranger to trials and tribulations, they always chose each other and their love. They have set the example. This is a significant reason why I eventually knew my experiences in romantic relationships were not ok; my whole life they showed me that I am worthy of love.

In all areas of my life, however, I was timid and afraid to ask for things I wanted or even needed. There is no real reason I can pinpoint, but I think part of it was simply natural behaviors that come with being the first and oldest child. If you're an oldest child, you probably know what I mean.

I was also simply never one to get in trouble; to this day I still get anxiety at the thought of disappointing someone, or giving anyone a reason to question my integrity. In a way, it felt like I was put on a pedestal by others. Whether by intention or otherwise, or simply by my own internalized

standard of perfection, when I did something out of character or "not ok," the disappointment always felt so huge.

My interest in boys peaked when I hit my pre-teen and teen years. Naturally at the same time, my body started to change. I was curvy, not thin like most of my friends. This made me feel different, and as the boys and girls started to pair off in couples, I was left wondering, "What about me?"

I had always been bigger than most of my peers, also shy, a little awkward and quirky too; never outcast, never popular either. Certainly never a girl to get much attention from the guys, I was just kinda there, in the middle somewhere, being told how cool I was, yet never cool enough to be their girlfriend. I was never made fun of or told I was ugly. They just… didn't choose me.

Is something wrong with me?

Is it because I'm fat?

Or not pretty enough?

Is it because I'm kind of shy?

Is it my lack of confidence?

Maybe I don't wear the right kind of clothes?

It's because I talk too much isn't it? Overcommunicator!

When there isn't a reason, it's easy to internalize. That is exactly what I did; I started to believe things about myself that were simply never true.

I talked with my parents about it, often crying, and they would always assure me that I was more than enough, beautiful as ever, my heart was good, I was worthy, and there would be someone perfect for me—that I deserved nothing but the best! I'll never forget the night I sat with my dad on the edge of the bed and he told me I was the kind of girl guys knew they would want to take home to their mama, they might just not be ready for that kind of commitment and seriousness yet. I'm forever grateful for the wisdom and love they continuously pour into me.

Heathy is the New Sexy

I wanted to be the "it" girl. So I tried a lot of things to stand out—diet, changed clothing style, the way I acted, spending hours on hair and makeup—nothing too major though, thank goodness. However, this led to extreme

dieting, trying everything I could come up with. Everyone and their second cousin was trying all the fad diets in the nineties.

Through my teens and early adulthood, I caught on and tried it all; everything from not eating, to potions, binge eating, excessive cardio, and diet pills. One of the more extreme things I tried was to only eat five bites of dinner with thirty-two ounces of water, and no other food all day during the week. On the weekends, I could eat anything I wanted, so I consumed a bunch of the treats customers or coworkers would bring into work, and fast food for lunch plus whatever else I could fit in. I'd get so, so sick. This was one of many things I did in trying to reach what I was conditioned by society to believe was the ideal body type. Thin was the only way to be viewed as beautiful and worthy in my mind. Later in life, I wondered why no one noticed what I was doing and how horribly bad it was for me, but dieting in those times was just so normal and socially accepted, even celebrated; everyone was doing it.

Something often said to me, by both men and women, "You have such a pretty face, if you could lose twenty pounds or so, you would be perfect." Ugh there is that word again—"perfect." In my mind, they were right, and twenty pounds seemed so easily doable, so off I went to find a new diet or miracle pill to try. I was always so close to the finish line, so it seemed.

Many times, men have even immediately let me know they like their women "thick" and would elaborate on why they didn't like skinny girls. I didn't ask! *Can we just stop idolizing body types and respect that we are all uniquely and beautifully different? Can we start to see, learn, and value people beyond their body?* I respect that we are all attracted to different things, but it doesn't make me feel better that someone looked at me, saw big boobs and booty, and decided I'm "thick" and they like that. *What about who I am as a person? Do you like her?* It also doesn't make me feel good when men talk about how and why they are not attracted to skinny girls. *Did they think it was appealing to me that they would talk horribly about a body type different from mine?* Absolutely not! Shaming other women for the benefit of making me feel better about my body is not right, it is a major turnoff!

STOP! Stop "fat shaming," stop "skinny shaming," please just stop! Stop making this about our bodies—it has absolutely nothing to do with who we are as humans, as women. We have hearts and souls that make us each special in who we are. Look there, look deeper. Our daughters are paying attention, and it is important we lead with respect and honor. No matter what size women are, or how different their body may be from others, appreciate the beauty within each of us. Women are sacred and incredible human beings, with different strengths and gifts that make us each unique in our own way.

It is not about choosing me, it is about respecting me—respecting women.

At this point, I couldn't see anything about myself beyond what was on the outside. Perhaps there is a time you felt this way, too? It feels pretty defeating, doesn't it?

I would always see short term results; when the pounds would drop, more compliments would come, and I was finally seen. I didn't realize at the time but that was my worst nightmare coming true. It really did take being thinner to be noticed, wanted, seen, and praised by most.

My body was in a constant state of fluctuation. I felt so frustrated and defeated. Why is this so difficult for me? In my mid-teens, I started going to the doctor for consistent recurring tummy aches, and difficulty losing weight. I got little-to-no help. Completely dismissed for years, even by specialists, I was always told I was fine, as healthy as can be. The words, "Everything is normal—eat less, exercise more," were the same answers I heard, every single time. They didn't even bother to ask me and learn that I was significantly under-eating most of the time; sometimes I hadn't eaten in days and I was doing hours of intense cardio every day. As you can imagine, I felt a lot of shame.

Again, I was the problem. My extreme efforts were not enough. This would then lead me to give up; it didn't matter anyway, my weight loss results were little-to-none, so why bother? Might as well eat and drink whatever. Well, until the next fad diet or miracle pill dropped. This cycle continued for years into adulthood—the "medical advice" that exacerbated my dieting and extreme efforts to lose weight which, in turn, continued to make me sick. This was the beginning of what ended up being years of stomach issues and weight challenges, which eventually turned into greater health issues. I had done a good deal of damage to my metabolism and gut by the time I was nineteen, all for the sake of being skinny.

In my mid-twenties, I found an incredible naturopathic doctor. At my first appointment, I sat in her office completely defeated, telling her she was my last sliver of hope, "I have debilitating stomach aches, loads of anxiety, and not even starving myself will work anymore to lose weight." She understood me. She saved me.

With her help I was able to get myself to the healthiest I have ever been in my entire life. I took her recommendations seriously to put my SIBO (Small Intestinal Bacterial Overgrowth) into remission, and manage my low-functioning thyroid. Dr. Jennifer Hawes is forever a hero.

Bonus! I lost a bunch of weight.

I am sure you can imagine where this is going—the boys came out of the woodwork. This time was a little different for me though, as I kind of hated it. *I am still the same Katie. If you didn't like me thirty pounds ago, you won't like*

me now. Or is the truth that I was fatter then, so you didn't deem me worthy of your attention? I was honestly repulsed by it. *If I wasn't worthy to you thirty pounds ago, you don't deserve me now.*

At this time, I met the man who would soon be my husband. He had no idea who I was before the weight loss—he didn't know me heavier—so it didn't feel like that was why he was interested and I let my walls down. Things progressed alarmingly fast and I truly thought this was it, my fairytale.

My body really enjoyed pregnancy, however postpartum sent my body spiraling down a black hole of hormone upset and the autoimmune thyroid disorder, Hashimotos. Dr. Jen and I continue to work together towards hormone and thyroid balance with health always at the forefront. I know now that being healthy is so important, and this is a lifetime commitment and goal of mine. Skinny doesn't always mean fit and healthy, fat doesn't always mean lazy and unhealthy. I show myself love by continuing to establish a healthy relationship with food and my body. Sometimes I still struggle with the urge to take extreme measures to lose weight, there is always some miracle product or diet that is seemingly making everyone else lose weight. I remind myself of the repercussions that have come along with those choices in the past.

I have embraced my body and I am grateful for all it has carried me through. I may not always love every part of my body, and that is ok, but I will always love me and all of who I AM, no matter what my body looks like.

Young Love

In high school, I finally had a few boyfriends. One of my first boyfriends had a rough homelife. I went over to his place one time; the entire apartment smelled of cigarettes and was dark and messy. I stayed, no judgment. We hung out, watched TV, listened to music, and made out like teens do. He would tell me how mean his dad was to him, especially since he always came home drunk, and he felt his dad was telling the truth about how worthless he was because, "the truth comes out when you are drunk." This just broke my heart for him. I never fell in love with him, but I felt his pain in my heart.

Fast forward a little bit and I decided I wanted to end the relationship. I let his best friend know so he could be there for him, and his response to me was that if I broke up with him, my boyfriend would kill himself. So I stayed.

For many many years, I subconsciously carried the weight of that statement with me. He ended up moving away and our relationship naturally ended, but that responsibility should have never been mine to carry. Still to this day, I struggle with the feeling of potentially hurting or upsetting people; regardless if it is due to boundaries or a natural consequence of their choices, I fear their reaction.

A little while later, the hot new guy in school had my full attention. My first love, we were high school sweethearts, just like my parents. After he so patiently waited for me to be ready, I lost my virginity to him. Thankfully, I can hold on to that moment as a forever good memory with him. We were together through the rest of high school and continued on a few years after we graduated—those were the best years of my teens and early adulthood. Our families absolutely adored and loved each of us. We took vacations together and split the holidays between all of our homes, making our rounds to be a part of both families. We lived together for a few years, shared bills, and had big dreams to grow together. Or so I thought; I truly believed at the time he was my forever.

Until he wasn't…

He broke my heart, shattered it. He cheated on me, again.

I laid in bed for days, crying until I had no tears left. I felt so empty and confused. This happened shortly after my dad had survived a cardiac arrest (a story for another time), but it was such a scary and sad season of my life, and he just left me, as if the last several years never mattered. We did try to work it out—I changed exactly what he asked and it still wasn't enough. I was never enough, always falling short in my efforts.

What hurt so deeply in these moments was the very thing that, later on, gave me the strength and courage to fight for myself forever more.

Finally, I did get out of bed. But I spent most of my nights at the bar where dinner was alcohol. I skipped dinner to save the calories, and the bloat. *Instaskinny, right?* I'd skip meals to appear skinnier for outings and events, in the hope to be more appealing. All that did was make me a cheap drunk.

Drinking until the effects of the alcohol surpassed the pain, I could put on a strong front, as if my heart wasn't lying on the floor. My ex-boyfriend would often show up with his new girlfriend, the girl he cheated on me with, and I would just pretend I was fine without him. Nothing about me was fine. His girlfriend and her friends would make comments like, "Here comes the fat cow," and so on. This continued for months. Not only was my heart deeply hurting, so was my self-image, which sent me spiraling deeper than ever into unhealthy habits for the sake of being skinny, in the hope to be loved.

I chose a path of destruction: binge drinking, skipping meals, partying, and sex.

At this point in my life, I truly believed that the way to a man's heart, what made me worthy of his love, was being skinnier and sleeping with him. If I could just be great in bed, he would see me, and value me. If I could just lose

twenty pounds, I would be seen and valued. So I would go out, get wasted to mask all of the insecurities and sadness, then give all of myself to someone who never intended to love me.

Eventually it emptied me. I no longer had motivation or purpose.

After that, I had a few more boyfriends, most of whom cheated on me. Those who didn't cheat still became super toxic, using the exact things that destroyed me prior to continue hurting me, and they knew it.

One boyfriend ghosted me after many months of being together, sleeping together, and spending nights at each other's house. He went to guys' night, I went to ladies' night, and that was the last night I heard from him for months. I was not only hurt but worried. Five weeks later, I found out he had a new girlfriend who was pregnant. I was left with no answers.

My latest boyfriend, I came to find out, was on a fetish dating site seeking threesomes behind my back. I very clearly communicated to him that was not an option for me, and once again, I couldn't be met with honest conversation and loyalty.

This continuous cycle of abandonment was not just abandonment, but abuse. How could I ever trust again? All I had ever experienced from my romantic relationships was pain.

Into the Masculine

Words from my first heartbreak rang in my mind, "You have no goals and dreams in life, you are perfectly content living in a cardboard box."

The truth was, I would love him no matter what, even if we had to live in a cardboard box. My words were taken out of context and used to hurt me. My love for him was unwavering.

On top of my full time job, I joined the network marketing industry, working even more to prove myself not only to him, and the world, but to myself. I wanted to make sure everyone knew I was perfectly capable of doing it all alone. "I'll show him," was my attitude, "I don't need a man!" I had internalized a fear of being alone and incapable. Toxically independent.

Working became another coping mechanism for me. The more I worked, the less time I had to worry about being alone. Additionally, I thought it would make me more appealing, so I didn't come off as "needy, clingy, and co-dependant." I was working so hard to paint over these words painted in my mind through verbal abuse. My careers have always been in male-dominant industries and there were times I was the only female employed

in my workplace. This was the perfect storm to catapult me into thriving in masculine energy.

To fill my free time, I stacked my schedule with business training in network marketing. Let me tell you, those rooms are always filled with positive people. The silver lining of all this overworking—I was surrounded by entrepreneurs who wanted me to win, too. This nudged me to look inward and move forward with my life, which in turn, started my healing journey. *Give me all the self-help books and training, am I right?* I was seen. Seen for something other than my body.

I started to see value in myself as a woman. During this time, I remained single for several years, and became very comfortable being alone. I must say, giving myself the space to feel comfortable alone, is the most valuable gift I have given myself. However, it was a valuable season, not a forever solution. It has taken me time to separate being ok alone, and closing myself off to the potential of a healthy relationship.

Divorce

This is a part of my journey I'm not quite ready to share the depths of, however it is a huge part of my story so I will share what I am ready to.

What seemed like my fairytale come true, ended as quickly as the clock striking midnight in Cinderella. Only there was no happy ending. The grief of a failed marriage is very real and raw. When the one you loved so fiercely, quickly becomes a stranger. The promise of forever is broken. The death of vows, commitment, love, and truth. For me, a failed marriage is a pain that can't be put into words; there is humility, resentment, and fear as the insecurities rage.

I fully believe in fighting for your marriage and I understand what the Bible says about marriage and divorce, but I think we sometimes get it wrong. We don't marry the person God intended for us to spend forever with. I never wanted to give up on my marriage. Begging God, with tears running down my cheeks and barely able to breathe, to guide me to love him better, to help him see me, to fix me, to save us. I fought so hard.

Until, one day, I just couldn't.

It took me quite some time to follow through with divorce, even after choosing to break the cycle and be done, I was separated for many years. I had extreme amounts of anxiety around divorce; all the feelings around it were emotionally and mentally paralyzing.

I don't really celebrate divorce, but I am free.

Free from my anger

Free from the debilitating anxiety and sadness

Free from resentment

Free from guilt

Free from questioning everything

Free from the weight of that long, grueling process

Free to move forward with my life.

I physically felt the weight lift away. Instantly, I saw myself as a better mother and better co-parent. That day, I became a stronger woman with so much more of myself to give!

That is worth celebrating.

Single Motherhood

I have a beautiful relationship with my daughter. It is secure, healthy, and happy. She is my adventure buddy and my best friend. I believe and know it is not her responsibility to save me, however God certainly knew what he was doing in blessing me with her. His timing is always perfect. I am so proud of us, all we have been through, and what we have built between us. I'm grateful beyond words for this journey in motherhood. The blessing is not lost on me, it is perfect and just as it was meant to be.

<center>***</center>

My journey in motherhood has been nothing like I imagined; it was never supposed to be this way. Despite a strong support system, it can be so lonely. Like when it's 10pm, your children are fighting sleep, and you become frustrated thinking about all of the things that still need to be done before you can go to bed: the dishes, tending to the pets, laundry, taking a shower, work, and the list goes on. I imagine it would be such a relief to say, "Hey, I'm tapped out, can you try putting them to sleep? I'll finish cleaning up the kitchen."

It is laying in bed in the middle of the night unable to sleep because you are anxious about something happening to you and no-one being there to help your child. Wondering how to have that conversation with a toddler or very vulnerable, young child.

It's also having the weight of the world on your shoulders. Making sure you have the financial, emotional, mental, and physical capabilities to fully support your child regardless of what you may be experiencing yourself. Truly one of the hardest things I ever had to do was be a good mom while healing from my traumas. I am proud of myself for that. I don't want my daughter to repeat these same behaviors, so it is up to me to break the chains—right now. While I had a beautiful childhood, and I struggle to relate when others talk about their childhood trauma, their wisdom has helped me understand the depths of the pain that comes with that. I do not want this to be the beginning of childhood trauma in my lineage. When I make decisions, I always lead with this question to myself, "What do I hope my daughter would do if she were ever in my same situation?" and then I move in that direction. Protecting her to the best of my ability through wisdom and boundaries is my job, and it is top priority.

Being a single mom has also left me feeling misunderstood at times. It feels as though single motherhood is viewed as being lucky, like it's a prize. I didn't ask for this, I didn't want it to be this way! I never wanted to do this alone. No matter how it's split between us, I have been robbed of the family dynamic and support roles I dreamed of and crave. The one I was promised. I wish so many things were different. It's a grieving process.

There is a mix of judgment and praise. There is a sense of being seen; while people do not always see the depths of it, they recognise there are challenges. Yet the moment I start to soften and admit that I actually want a man in our lives—to truly love me, and do life with me, with us, and set a healthy example of love for my daughter—I am deemed as codependent or unhealed and unable to be alone. People will comment, saying I need to learn to be single or to enjoy it. I wonder if they even know me at all? I have spent most of my adult life single and alone.

I know I am whole on my own. Having a man in your life does not mean you're codependent, it means you recognise your complementary strengths as a woman. Having a man in your life, grounded in his role, will only amplify who you are. A synergistic balance where the feminine and the masculine come together to complement each other and create harmony.

I believe women were created to be held by a Man—fuck the societal and cultural crap that celebrates women "doing it all alone." While this has its place, it's not how God intended us to thrive. We, as humans, were designed to do life together. I am no longer afraid of admitting that it is hard to do everything with no support system in the home. I don't want to do it alone anymore. I want someone to share love and life with, to make memories with. To experience a healthy love. This makes me no less strong, capable, worthy, or attractive.

I am ready to soften, to let go of a lot of this masculine energy I am carrying, and let more of my feminine energy flow, to create a balance with the one who is meant for me. I truly trust God has it all figured out.

I once had a vision during a guided hypnosis session where I was going along a long trail through all different terrains and weather. During parts of the journey I was running, whereas other times I was taking a slow walk. Some parts were hard and some peaceful. Eventually I came to a big circular area cleared in the forest, where a man was standing with his back to me. There was another trail alongside mine that led to the same circle, and one more trail on the opposite side of this circle. What resonated for me was that the one man truly meant for me is on his own path and, one day, we will come together in the right place and the right time, and we will continue on a new path together, on the other side of all this mess. The moment we come together it will be clear, and peaceful. I have no idea where that trail will lead but I have all the faith that it is going to be a beautiful journey, with its own terrain, and I won't have to go forward alone anymore.

The Healing, a Forever Journey

While I had done a lot of personal growth before my marriage, it was after my marriage was over that I really sat with myself in the pain of all I had experienced in my romantic relationships. This was a choice I had to make when I was ready to actually face the reality of all I've been through. It hasn't just been relationships and my weight, there is so much more to what makes me, me. It was incredibly hard, and sometimes it sucked, to sit in that reality. Alone. I went to therapy, leaned into my friends and family a lot, joined coaching containers, read, prayed, and journaled; but it took me to decide that I was worth healing, and no one can do that for me, but me.

Throughout my journey, I found my way back into the church and established a real relationship with Jesus, my savior. Evil still exists, so I was not exempt from tough shit, as you have likely realized by now, but what I know to be true for me was that it was a lot easier to experience the hard stuff with faith. I learned that my most powerful tool was being grateful for what I had right now, while praying for the things I wanted. A friend once told me, "God's greatest gift is wisdom, and wisdom comes from experience." From that moment forward, I knew there was purpose in the pain. I knew that I was meant to share, to be a light of hope for others, and I was never alone.

After all this time, I finally understood what attracted me to these men. Most of them didn't have a childhood like I did. Seeing brokenness and deep sadness in their eyes, I wanted to show them a love that was different, the kind of love I had received my whole life from my family, a love that was truly unconditional and unwavering. Maybe they did get a glimpse; I hope so. The

unfortunate truth is that I became collateral damage to the fact that they were not ready to receive that love.

You can not love someone into being a good human. There is no amount of love that can change a person who is not ready to put in the work themselves. Love is not enough. Protect yourself and love them from a distance. You do not have to put yourself in the line of danger, abuse, or disrespect in the name of love. That isn't love at all. I encourage you to establish boundaries and allow yourself to step into a healthy life. To work towards being emotionally, physically, mentally, financially, and spiritually healthy. You deserve that, and you do not owe anyone any part of you they did not earn.

All along I was never the problem.
It never was about me.
I'm not responsible for their choices.

There is beauty and value in my imperfections, I am whole just as I am. Worthy of all I desire, and that is not defined by the weight of my body.

Coming Back To You

When being in the depths of toxic and unhealthy relationships, often blinded by love and consumed with hope, we don't always see the reality of the situation very clearly. I know there were times I felt like I was crazy, as though what I was experiencing was not real, or that I was just blowing it out of proportion, and a feeling of insecurity had overcome my entire being. Feeling like I need to change who I am; my body, personality, career, attitude and more. I was simply losing myself in the process.

I started to ask myself some hard questions, to hopefully reveal some truth.

How will changing yourself change their behaviors?

How will it feel when you change all of what makes you, you, and there is no resolve? Can you happily maintain who you are not?

Do they deserve you, if you have to shove down what makes you special and unique?

Do you think love is supposed to hurt like this?

If you feel like you are possibly losing who you are in the process of trying to save, or fix, a relationship, but all it is doing is hurting you, I invite you to take responsibility for the one thing you have control of: **your healing**. The journey is waiting to be ignited in you! This is going to require you to ask yourself some hard questions, to gain clarity in your truth. Your truth matters, and it has already been planted within you.

To support you in starting or going deeper on your own journey, I offer you some of the journaling prompts that have helped me along my journey. Create space for yourself as you dive in :

1. Write a letter, or create a voice recording, to someone you would like to fully express your feelings to, or stand up to. With full honesty, be savage, go all in. Do not hold back any emotions, don't worry about flow, or if it makes sense. Let it all out. Release the resentment, the anger, the sadness, and

confusion. Let them know what is hurting you, and how it is making you feel.

Perhaps you fear the repercussions if you followed through with delivery of these messages, but know these are *your* sacred words. No one ever has to see them or hear them. When you are done, you can burn them if that makes you feel comfortable. Or, keep them somewhere for later. Something I do know is that when I am of a stronger mindset, I allow myself to go back and read some of these to reflect on. You can be proud of how far you have come, and be able to see how much goodness has replaced the space of all the resentment, anger, and sadness you were holding on to.

2. *Write a letter to yourself. Forgive yourself for what you didn't know then (you decide when "then" is). Give yourself the opportunity to release what is holding you back; the mistakes, the guilt, the resentment, the fears. Open up your heart, and give yourself permission to move forward, to be seen, and to receive. You are worthy of all you desire.*

3. *What does a healthy romantic relationship feel like to you? Let's do this differently, we are not making a list of things we like in our partner. Instead, I encourage you to write about what a healthy relationship FEELS like to you.*

4. *Write a letter to your body. Share all the things you love, the promises you want to make, seek forgiveness for the times you did not show your body love. Give yourself a lot of grace here.*

Use the following blank pages to take this work deeper.

She remembered who she was and the game changed

CHAPTER SEVEN

Transcendence

The winds of change carry the scent of softness, tinted with jasmine and red rose. If you are reading this, there are gifts here for you to open to receive, through the spaciousness in between words, the hidden rest in the pauses, and the traction moving through them.

I am a Mystic, Medicine Woman, Channel and lead in Divine Feminine Devotion. I access information from the cosmos through the frequency of Goddess energy in whatever way it is translated to me. She speaks to me in the pastel sky, crescent moon, and sun-kissed rivers. She shows up in my healings through angels, cherubs, and golden orbs. She is the empathy in my heart. She is also the eternal flame that protects against all cost, and burns down that which is no longer serving. Her insight has the capacity to see through illusion and cut away distortion from knowing both creation and death.

My capacity to work with energy and access intuitive insight comes from the exploration of the life, death, life cycle within. I have died many times staring pain in the face, shedding layers, and transcending it.

My personal experience with sexual trauma, I call a Shamanic Initiation as it was the pivotal one-eighty that turned my eye within to find myself, higher guidance, and to connect to sovereignty. It gently ushered me into what the Indigenous Australians call "Dadirri," the deep inner listening and quiet awareness that resides inside, that can later translate into a spiritual skill. This, the capacity to hear beyond words into the depths of intelligence residing at the seat of the soul.

Trusting inner guidance led me to jungles where medicine people reside. To homes of people who carry magic in their blood. To tea with wise women. To humble myself beside the fires of magical men. To temples in the sky. To sacred texts. To many countries radiating diversity. To high energy vortexes on the planet. To stillness. All have been my teachers.

Inevitably the most trusted teacher has been me, the wound, the catalyst to master alchemy. This wisdom is what I want to share with you. You hold the key to ultimate healing—and that key is found within.

This chapter that follows is the result of the hero's journey, seen through a healer's eyes. It is my wish that it inspires the hero within you to keep going, no matter the trials or the time that it takes. Shine the light that only you are

here to bring. Break when you need to, cry when you need to, and when you are ready, fly!

I want to clarify that when I speak to healing, I am talking on a quantum level through the metaphysics of the collective, ancestral, and past life timelines, as well as the mental and emotional obstructions that reside within. These can and do create physical issues. Clearing disturbances translates into the physical structure of the body, raising the energetics and activating the body's own natural healing restoration system.

There is no guide book for the journey of the soul. There is no one quick fix for holistic healing. There is no way to know the magic you will witness in your awakening. All are mysteries. There is, however, a commonality that runs through us. We are all connected by the same thread and are in this evolution together.

So, let us not leave anyone behind.

Channelling

I always receive intuitive or psychic guidance when upleveling beyond my comfort zone in my lightwork. Being in service to something bigger than me that supports transformation for others often means laying down my personal agenda to allow a clear channel of energy and wisdom through me.

With my eyes wide open staring out into the emptiness of a dark room, I began to witness images that came with rhythm—vivid, transparent, jarring, intriguing and complicated.

For those of you who are new to understanding transcendental experience, it is like watching a screen play out in front of you but with an all inclusive knowledge of the building blocks behind the images. You can also receive only one image but it can come with multiple layers of information. Psychic development is the extreme cultivation of intuition. Have you ever had a "gut" feeling about something that your logical mind can't make sense of, only to find out that your inner knowing was correct? That's your intuition accessing messages through frequency, which you have the capacity to enhance if desired.

This particular channeled intuitive insight came to me the night before my first ever *Global Womanhood Womb Healing*. It was given to me to serve a purpose connected to the healing I was to embark upon, as I set up to clear out old cellular memory of abuse and trauma, and restore new found vitality and pleasure into the pelvic bowl. Perhaps it also came through to share in this book, *Becoming Whole Again*, for you to receive?

During the vision my senses became sharp, as if remote viewing from eagle to prey, simultaneously seeing each viewpoint with detail. I was both the outside viewer and the embodiment of a youthful girl moving amongst wildflowers. A long, lightweight blue cloth enveloped her legs, with only her golden hair to cover her breasts. Drinking in the air through her porcelain skin, she moved with grace, the elements her ally. The warm dust beneath her bare feet held her like a loving grandfather would, cherishing connection. The mountains safeguarded as she ran freely in the meadow with a tranquil ocean of sky above and within her. She was untethered, sensual, trusting, and strong, knowing how to claim both the sacred and wild feminine. What struck me most is that she felt, and was, fully *SAFE in her body and upon the earth.* It was such an extremely enlightening experience to feel within me, as a woman who carries a sense of unsafety. As perhaps, on some level, most women currently do?

I was being shown the possibilities of the New Earth frequencies, where trauma was profoundly released and higher unity consciousness embodied in humanity. I know this sounds like a wide concept but it's not as far away as one might think!

The wounded collective womanhood had released the deep anger, powerlessness, disempowerment, and sorrow that kept victimhood alive. The wounded collective masculine which had faced aspects of inner turmoil, fear of failure, avoidance, instability, and misuse of power learned how to give themselves permission to deeply feel and, thus, restore separation. This allowed a stronger aspect of safeguarding with coherent intent through them, as powerful protectors for themselves and others. Between both sexes there was a reverence for each other's fundamental qualities and a celebrated reciprocity of the unique gifts that both the masculine and feminine innately provide.

It was clearly highlighted to me in this vision that the girl's womanhood had never been violated, abused or mistreated; she was protected and uplifted, and thus, could share her gifts back through unscathed radiance, reminding the masculine of its true potential.

Spirit had come through to offer me a glimpse of what is possible to attain when society heals and matures. In order to collectively raise our frequency we must let go of the unprocessed trauma that remains. How we get there is an inside job. It hinges on self-responsibility, receptivity, authenticity, vulnerability, respect, love, and an openness to do things differently.

Sacred Feminine

The medicine in the feminine is to surrender wholeheartedly. She can only surrender fully when she feels safe enough to let go. She can only let go when she can receive. She can only receive when she feels worthy enough to do so.

Throughout history, womanhood has endured aspects of un-namable brutality at the hands of hollow hearts. This echo remains.

*The Trust **Was** Broken.*

For many women there is an underlying saturated fear that the world is not safe, that she is not safe or perhaps, even worthy of safety; screaming inside, hardening in trepidation, separating from the very magic she carries within herself.

Hope is not lost. We can dismantle and unlearn outdated patterns of control and amplify capacity to access natural surrender, an elixir of freedom, that is ours for the taking. The divine feminine frequencies rising at this time are present to restore balance to where humanity has gone off course, calling us all back home to the medicine within the *Wings Of The Heart*. Yum!

No matter what has been bestowed upon the body, past life or present cannot take away from the radiant, encompassing, essence of multidimensional light that we are, which cannot be extinguished. Pressure will not break us, only form us into diamonds that glow brightly, celebrated for their truly rare and powerful beauty.

Wild Feminine

I find my wild feminine speaks loudly during my menstrual cycle, revealing cracks and distortion in the collective, ancestral, and personal field that are screaming for attention.

Sometimes around my moon time, I am rage that never erupts. My senses become heightened like a wolf in the winter trees searching for rations. I become ravenous like a bear who hasn't eaten for weeks. No matter how much I consume, I am never satiated. Unusual cravings present themselves whilst other foods repel to the core, the body rejects before either touch or taste, pre-purging a trigger or emotion I have stuffed down in the past. I feel anxious, I feel angry, I feel deep. I am primal and fractured, powerful and tired. I am a dormant volcano steeped in collective ancient pain, forgotten cries, and devastation.

My purpose on this earth is to be in service to humanity; the shadow side of it is the overgiving. An angelic voice that heals others with a personal voice that

finds it hard to speak my own needs into existence. The well known archetype of the wounded healer with a big heart and tears for eternity. Despite the intensity, this path would not be presented before me if I wasn't able to hold it and hold it well.

During my bleeding or those many times I need to do self-healing, I claim my belonging and right to exist. I get called into a cave and placed there. Here I am, in the void and forced to stop. I become present to all that is underneath the surface. I tend to the deep waters of the emotional inner terrain, negative belief systems and song of the soul. I wonder, do you ever create the necessary quiet needed to truly hear your song? There is a sweet melody to it that comes with a powerfully divine blessing!

Amongst the noise of this fast-paced modern circus, I intentionally create the space to care for the open wounds that would otherwise be left unchecked. Sometimes I simply let myself "be." Drinking in the gift of the earth, ancestors, angels, animals, and love that holds me, through gratitude. I surrender, and suddenly there's a radical honesty that rises up presenting a mirror to the contraction, exhaustion, confusion, and numbness. Uncomfortable, raw, truths exposed. With courage, I look rather than shy away.

Underneath that there's a portal to pleasure and magic that opens. Oh, there it is, tenderness. How delicious it is to simply let go. To let the walls down and recognise my right to be soft. Here, I reclaim the parts of me I have rejected, repressed, and pushed away, armored up to simply get through or play the part, in a society full of holes.

We cannot spiritually bypass our humanness. There is simply minimal room left for avoidance because the veil in our times is much thinner as we birth into the new authentic ways of being, and structures around us fall. Now is a vital time to allow release of old residual, un-serving energies, ancestral pain, and lower level beliefs. We must turn to face ourselves, in all that we are, loving over rejecting as we maneuver the seasons of existence. Installing and imprinting the truth that we are lovable and worthy of love. We always have been and always will be, but the practice is remembering and sometimes, re-remembering.

Sacred Rage circles have helped me release anger, sadness, and stored painful emotion that blocked love. *Sisterhood* circles have provided nurture, shelter, and evolution. Seeking and allowing support from other *Healers* has been vital on my journey to learn how to deeply receive, be held, and maintain a healthy body.

Often if trauma is experienced, we attempt to struggle and push away the parts of ourselves that we deem unacceptable, and in doing, so the rope tightens. This can sometimes mean abandoning aspects of the feminine nature to more masculine tendencies to simply get through. Being rigid, holding on

tightly in contraction, or moving from an overly logically dominated mind, can mean we attract more dense experiences to us or simply see through a distorted lens, being closed off and unreceptive to love or the wisdom of the body.

Mother, Father, Child

Of course, I did not know this as a teenager. Underneath the exterior, I was so desperately looking to fill a bottomless hole from the belief that I was unworthy of love.

My parents had split when my mother was pregnant; they gave it another go when I came along. We lived in a Teepee in Wales, so much of the days were spent tending to basic needs of collecting wood for warmth, swimming in cold water to bathe, and weaving magic through simple living. My mother and sister were pregnant at the same time. I was born into my beautiful sister's hands and gently passed around the fire through a circle of loving souls within the community. I feel a sense of comfort in being born so close to nature, and outside of western societies norms, to such a special family. I know my mother was happiest when she was close to the earth and sharing her joy with like-minded souls; it brought grounded vitality to her spirit. My mother was, truly, an incredible woman who carried a unique wisdom in her bones and a magical heart that simply saw the best in others, which naturally attracted people close to her side. She had a light that was rare and did an amazing job of raising me, and even though mistakes were made, she always gave me presence and unconditional love.

Despite this alternative start, I have had moments when I have energetically and visually transgressed to when I was a fetus inside the womb. I could feel my mothers dejected emotions and sense my fathers distant despondence. In the times this unexpectedly happened, I attempted to heal my mothers sadness and a void in my fathers heart.

My father left when I was four. It was the right thing to do. I used to hear my parents shout so loud it issued a fright in me that still reverberates from my child's nervous system to my adult's. One day they were arguing, an opposite mix of fire and water battling out the elements. Their hidden wounds, unhealed inner children, and buried cries seeping through the blaring tones vibrating to meet each other in detonation. I was placed outside a door but what good did that do if I could still hear and *feel*.

I wished I was transported to the colorful world of Alice In Wonderland, in the hope to find that cake, labeled "eat me" to make me grow bigger. Or was it a mushroom? Either way, I would have devoured it! The door latch was way too high. I tried standing on my tiptoes, no luck! I used to pick up changes

in energies in different spaces that I didn't yet understand—spirits and frequency—this, however, translated into intense fear at times.

Imagined or not, at this moment whilst my parents screamed, there was a pitch black entity coming down the stairs and approaching, fast. I am sure it was just fear but it seemed real through my entire little body. The energy of dread had fully set in, setting a fright into my system that still remains playing out as hypervigilance to my environment and people.

I was paralyzed and had no shores to safety.

Inner Child Healing

As an adult, it's easy to miss the needs of my inner child, yet this is such an important part of healing and self-care. She has been faint and fiercely shy, yet when I don't listen to her, it has had massive knock-on effects, abrasive intuitive pangs, and behaviors that are irrational and sometimes unsafe.

The inner child is an important aspect of the psyche for absolutely anyone to attend to. What a parent doesn't take ownership for within themselves, a child absolutely can absorb. Survival depends on the parents or caregivers, so the emotional fluctuations, disappointments, let-downs, shutdowns, avoidance, shouting, over-smothering, abuse… the child will internalize their own identity, often making it mean there is something wrong with them. Despite parents' best efforts, the child will form an attachment system that is based on staying alive, often adopting either an egoistic type belief pattern, "I must look after me to survive" or the people pleaser's response, "I must look after you to survive." Each has learning and strengths encoded in them for us to grow if we choose, and a scale of intensity based on the psychological patterning from the experience. I developed a people pleaser response to assist in bandaging my mothers painful emotions, and abandonment with my father's connection. Abandonment meant that, on some level, I learned that love is pain.

As we mature, trauma bonding can form in relationships as a result of the unhealed inner child seeking the emotional frequency they knew and beliefs they developed, which can play out as a dance between the victim and the perpetrator, the codependent and the narcissist. If the cycle is not caught early, and continues behind closed doors, it can lead to extreme disempowerment and a shutdown in the energetic system, which creates all kinds of problems in all kinds of ways. These relationships can be a valuable source for learning and provide great contrast for understanding what is wanted or not wanted. How long we stay past the point of learning completely correlates to self-worth and the ability to distinguish between your wounded child's attachment and the capacity to hear and take action in accordance with our intuition.

I know this because in romantic relationships, I had once allowed emotionally abusive behaviors, selfishness, shutdown, and disrespect, amongst a playground of escapism, avoidance, and codependent patterning. Pouring out, holding empathetic space when I had little to give; watching them thrive whilst I died. All the time my feminine yearning to be met in the heart. Sensual, Soft, and Sacred.

I now see how many times I did not listen to my body's initial intuitive responses or feelings—the sinking in the stomach or the contraction in my womb. I crossed my boundaries, doing what I thought I "should do," and in doing so, disempowered myself, depleting my health, heart, mind, soul and… bank account.

Relationships are teachers back to ourselves, and if we have an aspect of childhood or relational trauma, then relationships and human connection is a vital way through. My advice, however, is do not settle for something that is hurting you and not bringing you joy. And if abuse is present, leave.

Healthy relationships come with love and respect, but people can only love another to the depth that they have come to love and know themselves. If the inner child felt abandoned, neglected or unloved as they made sense of reality, then it becomes up to us to provide the nurture needed as we become adults by taking the time to re-parent within.

When I started to create the presence and capacity to listen to my little girl, she was distant and untrusting. I built her a safe environment adorned with flowers, surrounded by water, and housed with honor. She still has fear of being seen and heard but she now has more space. Here she expresses to me her desires to play with color, move with spontaneity, celebrate beauty in others, and be seen in her innocent beauty, laugh hard, and run freely with wild horses.

I made the conscious choice to no longer abandon myself or my inner child. It was powerful and changed everything. I now attract healthy masculine figures into my life. The once red flags that looked green are now red flags that look red.

As women, learning how to truly value our own needs is important because we have a blueprint that is geared towards empathetically giving out, to assure the nurture and balance of the "unit." Learning how to hear our needs is the first step, and with practice and connection to a sense of self, honoring them is entirely possible.

If this is something you choose, remember that it takes refinement. Mistakes are likely to be made and that's ok! I still fuck up. What has helped is listening to my intuitive inner compass when making decisions.

If it is not a strong charge indicating a "Yes," then it's a "No." Generally, if something feels light and exciting it's a go; if it's heavy and weighted, your intuition is inviting you to take more consideration.

When communicating in a relationship with a family member, friend, colleague or partner, I find taking a pause to listen to my inner guidance is incredibly helpful before actioning or moving forward. Move gently when making changes towards growth, knowing that each seed planted on the inner world begins a fresh garden of potential for the outer reality.

Sexual Trauma

Teenage time was a constant hopscotch of negative self-talk seeded from self-doubt, body shame, low confidence, comparison, anxiety, and self deprivation fuelled from the unseen wounded child and wild feminine attributes that translated into a love for the loss of control.

With limited boundaries and a soul that has traversed many lifetimes of repression and persecution in a female body, I remember carrying a sense of wrongness within a deep ocean, amidst bottomless, jet black, thundering waves of desolation that had no way to channel free. I became promiscuous as a way to unconsciously run from unwanted painful emotion, looking to satiate the hungry ghost whilst being closely connected to the mystical lifeforce and passionate energies that I didn't yet know how to wield. With a key I didn't yet know how to use.

When I was fourteen, my mother was given the opportunity to take us on a trip to Africa after a season of working hard as a gardener in snow and ice. We were both excited to embark on an adventure and to witness the hilltops highlighted by a new setting sun. I will never forget the feeling of first being on an aeroplane, which sparked my love for travel. However, I did not realize that my mother was internally unequipped to manage the chaos and danger that can present itself in foreign lands. As soon as we arrived, we were targets tugged in innumerable directions and caught in the gaze of starving eyes. In honesty, part of myself admired the attention. As women, we have been programmed to believe that our body and sexuality is a kind of currency connected to our worth! But I was not yet a woman. My mind was young and I was immature.

Soon after we arrived, my mum began drinking again after years of battling with addiction. The most beautiful, grounded, joyous, spiritual woman would turn quickly into eliciting harsh words and anger. Her drinking restarted after meeting two local African men, Omar and Mosis, who "groomed" us and trapped us in an adhesive web of deceit. They played on seductive charm, my mum fell instantly "in love," led by the heart of the rescuer. I had a boyfriend

back home whose photo I carried in my pocket but whatever I knew of innocent romance came crashing down fairly quickly.

Intoxicated by unfamiliar surroundings, alcohol, and the imposing male figure with a wide, but fraudulent smile geared for survival, I lost myself. I lost the ground, my bearings, and my values. I made a choice that would inevitably change the course of my life forever. I chose to sleep with him, unaware of the dangers, throwing my old reality away and exchanging it for new. This choice came at a major cost. I quickly became sick. This whole experience was far too much for my etheric body.

I allowed in the energy of sexual distortion and wounding. I say "allowed" because I consented. The energetics, however, were of deceit and darkness; our safety was not a concern, only their earnings, of which they took. We were both naive but I recognise my mum didn't keep me safe. I also watched her in agony, feeling immense guilt and shame as she watched me suffer. I blame myself and I blame her, but my love for her has overridden my capacity to fully process it. The experience carved into me, taking up space and modifying me.

My young teenage body and neural network changed. *My sense of purity and perception of wholeness—gone*. I developed internal pain, began getting regular urinary infections and this snowballed into a form of PTSD.

It was a trip from hell. I ended up in hospital for the remainder of the holiday with second-degree burns and sunstroke so severe that when I stood up, I went blind. I had blisters all over my skin except from where my swimming costume covered me, which thankfully allowed a space for the morphine to be injected. From media influence, my teenage mind believed the sun would make my skin brown—and that equaled beauty. This totally over-rode the thought process to apply the factor fifty sun cream before heading out on an old boat with no cover, enticed by fake-selling of "snorkeling." The water was choppy and the intensity of the African sun was heavily amplified by the sea's reflection. I don't remember seeing any phosphorescent beauty, swimming fish, or reef. I do remember feeling unusually thirsty, frustrated, and stuck. In the space of one month, I had become deeply scarred. This stemmed from the root of society's subliminal influence that a woman's worth comes from male attention or the external presentation of self.

Kept hidden under smiles and fake laughs, the years rolled in: suffering disguised, trauma amplifying, pain consistent. I believed I was broken and this manifested into physical disharmony where I attracted more incidents to me that reaffirmed my sexually "wounded womanhood."

After my mum passed away in my early twenties, it became clear why she had allowed this type of unbalanced behavior within a mile of us. She grew up in

a home where she herself was unsafe. Her sister was being sexually abused by her father. After her passing, our family received news of the possibility she was also exposed to indecent sexual expressions, but she never shared this with us. Looking back, there were signs!

There is a pattern in my ancestral line of sexual abuse. Her father had also been sexually abused. And down the line it goes…

I think this speaks to an underlying issue of trauma within the male psyche that has become damaged, looking for love in distorted ways. Perhaps this is connected to their own disempowerment over generations forced to fight and kill in war by an overshadowing governmental power. Can you imagine what it would be like to return back to a family home after grating gun shots, blood, and bombs? Waking in the night, screaming for the terror to be released? Drowning sorrows in alcohol to divorce all feeling? Living in a culture that does not support men to express clear emotion and allow important tears to fall, would of course, have disruptions. I know this is only one piece of the jigsaw, but I feel it is an important one to acknowledge for our men's healing.

Sexual disharmony is a hard topic to name, restore from, and bring forgiveness to. I wonder how many people reading this are secretly on this journey, even if it has played out within a close "loving" relationship.

I see that if we don't speak up or name it, keeping secrets masked, then when will it have space to clear from the psyche of our collective? Whatever we resist simply does persist, as it carries a charge that hasn't been released. If we bring light to it, we have the capacity to clear the fear, guilt, and shame prohibiting our connection to wholeness.

I know the frequency of sexual trauma and abuse in my ancestral line and previous past lives was re-created from a pattern that in this lifetime, I am here to Chain-Break! I help other women do the same. I have witnessed many variations of obstructions in the energetics when assisting in transmuting insidious or trapped wounding.

If you are reading this it is likely you have tread through mud to get here, fallen over, got back up, and are still going. Please know that your healing comes with meaning. It carries a wider purpose if you are courageous enough to look. It is my invitation here for you to further ignite the light warrior within you—keep shining and do not ever yield!

Whisper on the Wind

Over time, I have used psychedelic plant medicines to assist me on my path to healing. I advocate it only if you are called to it, otherwise it's not for your soul. Sometimes they have been gentle, presenting prayer hands in the sky and

opening in my heart; other times, extremely deep. On one occasion I caught a whisper on the wind, one I will never forget.

This I received through my third eye. I watched it travel down through the leaves against a backdrop of gray sky, skirt the branches, kiss the speckled bark, and translate dialogue in my left ear from my Native American ancestors and past life. Here in this vision, I was part of a stabilized, revenant, connected tribe. I had my place, was taught well, felt loved in the unit and was content. There was harmony in self, there was harmony amongst us. There was a harmony born through interconnectivity, simplicity, unspoken silence, respect for the sacred, and connection to the earth.

As the vision evolved, I watched Europeans storm the tribe, striking all in its path like lightning to an ancient tree. I do not feel called to go into detail of this, as we all know what war entails, with rape, abuse, and killing, and the visual burden is mine to carry. However, I will ask by invocation and inquiry:

Why is it that, in the past, we have tried to eradicate diversity rather than embrace it? Why is it that so many spiritual tribes have been diminished, repressed, or caged into an existence they don't want to live? How could it possibly be that, as a species, we have killed for fun? Why is it that when I looked into the eyes of the First Nations People, I wanted to scream for the injustice placed on their souls?

We all know in our heart what is right and wrong! Why do crimes against humanity get the chance to continue if we are so "intelligent?"

I will end here by sharing the completion of this vision and experience which is calling us into *forgiveness and, thus, balance*. Amongst the violence and pain, I was drawn to a medicine woman before death who looked directly into my eyes and shared this which I am honored to share here with you to receive today:

"Carry the Medicine Child!
Remember Grace.
 Forgive, they Hurt.
My Body Will Die Now
But
Sacred Wisdom Will Live On"

<p align="center">**"UPHOLD PEACE WITHOUT THORNS"**</p>

The Key

The divinity moving through us, as well as any wounding or trauma experienced within the human journey, carries potentiality—a school of learning. Both express capacity for evolution which can be used as tools for development, healing, and creativity.

In The Tarot, the devil represents the part of ourselves and the negative forces that hold us back. The halo above the hanged man's head represents that higher learning and enlightenment can come through the trials of life. If we look at the Yin and Yang in Chinese philosophy, it represents how the dark and the light are two complementary principles that maintain harmony within the universe and influence vibration from it. We hold both thunder and spaciousness between our blood and soul. We are the perfect storm, co-creating with a universal presence that supports us.

Inner healing is complex but it also has a simplicity to it. The simplicity must come from a place of trust that you hold the key within you and that healing is possible. This key comes directly from love, which happens to be the fabric that binds our universal creation so it can be called upon at any time! Love categorically transforms fear, as it naturally carries a higher vibration.

There is a kind of exhale and rest when we stop striving and pull into *acceptance* of exactly who we are, scars and all. Not to be defined by trauma but to use it to amplify and as a further gateway into self-love. This takes putting down the sword, dropping the armour, taking off the mask, letting go, and initiating into self approval. In acceptance and presence we can come to contact the omnipresent nature of our existence, from here we let in more of life and love. The entangled inner noise and worry quiets, leaving space for the unwavering song of the soul, where we will forever be liberated no matter what cards of life we have been dealt. In order to find ourselves we must dismantle all that is standing in the way. Remember, you have the *key*!

As a child, I used to chase rainbows in the hunt for gold at the end. It wasn't long before I realized it was indeed the journey, and not the destination, that was the treasure.

> Change looking outwardly and look inwardly.
>
> Change the thought that you "can't," because you "can!"
>
> Change the belief patterns that are self-deprecating and make you accept less than you're worth.
>
> Change avoiding that thing you don't want to feel but your inner child does, so you can be free.

Change giving your power away to the concerns of other people's projections.

Change withholding the expression of your truth, as your voice is needed.

Change impermeable boundaries, for you deserve protection and care.

Change repeating cycles that perpetuate and hurt you.
Change running from your intuition, mother, maiden, crone.

Change holding on to what no longer serves you and move forward unapologetically.

Change your perception of the Wound and use it to Blossom.

TRANSCENDENCE KEY

*"Inner healing is complex but it also has a simplicity to it.
The simplicity must come from a place of trust that you hold the key within you and that healing is possible.
This key comes directly from love, which happens to be the fabric that binds our universal creation so it can be called upon at any time!
Love categorically transforms fear, as it naturally carries a higher vibration."*

The exercise that follows offers you a tool to amplify Alignment, Manifestation, and Healing. Here, accessing subtlety becomes a currency for transcendence. This is a teaching for you to enhance your Intuition and to trust your Higher Soul Guidance.

Exercise:

I invite you to summon an inner key and use it to unlock what holds you back from living your elevated path of wider freedom, intimacy, health, and prosperity.

This *Transcendence Key*, presenting in whatever form it takes, is multidimensional love light. Grace and Divinity manifested through you, in co-creation with the universe as a heavenly vibration taking shape, for you to utilize. This could be shown to you within a split second when you ask, so don't get too tied up worrying about time!

The way you experience this shows up through your entire "intuitive sensate body." This means exploring the omnipresent, sentient aspect of yourself through using your feeling, emotion, imagination, and senses.

To give you an example, when I asked my higher spirit for my *Transcendence Key*, it appeared pearlescent within my mind's eye. It was radiating different tones of white, silver, and extremely gentle rainbow light, appearing like the phenomenon of certain surfaces that gradually change color and illumination based on the angle. The goddess Afrodite appeared, representing love, sensuality, and beauty. I also felt an incredibly high Angelic presence. Since then, I utilise these energetics to raise frequency from a low level to an elevated vibration when doing self-healing or healing for others.

PRACTICE

1. In a comfortable environment close your eyes.

2. Turn your consciousness inwards and intentionally ask your higher self: "What does my Transcendence Key look like?"

3. Open to trusting Higher Inner Guidance, even if this is a new experience for you!

4. Watch for what unfolds through your intuitive sensate body: Feeling, Knowing, Visuals, Colour, Texture, Sound, Information… and perhaps even one or multiple numbers of your Spirit Guides will appear!

5. Give this as much time as feels congruent to you.

6. When complete, open your eyes and know that you have just had a sacred experience.

Whatever is presented before you is a tonic for trust in the universal forces that are here to support you at all times, and if called upon, can be amplified appearing in life as manifestations in both subtle and profound ways to help you move forward.

On the following blank pages I invite you to explore these journaling prompts:

1. What does your Transcendence Key look, feel, and present as?

2. *Draw a picture of your Transcendence Key, using color if possible!*

3. *What happens when you invoke the energetics of your Key and use it to channel into any area of your life where you feel a blockage, with the intention of alignment, manifestation or healing?*

4. What is getting in the way of trusting Higher Soul Guidance?

5. Explore Intuitive Writing, answering the sentence: "Higher-Self, what is it I need to know right now that will assist me to grow?"

TRANSCENDENCE KEY

*Pick your hard, it's going to be hard either way…
so you may as well pick the healing over the hurt.*

CHAPTER EIGHT

Coming Back Home

"It's amazing what grows when you stop watering rocks"
Lindsay Hart

God's hand is all over my story, saving me time and time again. And He, too, has his hand at your back. I didn't always feel like this. At times, there was a lot of pain, hurt, and misunderstanding in being the outcast and feeling judged as I struggled to find my way back home.

Growing up with a close relationship with my mom, she would always say, "Do the work." I never understood what she meant. Maybe I was too young, maybe I was afraid of that responsibility, maybe I just grew up in a home where it was a "Do as I say, not as I do" scenario. In my childhood home, healing oneself wasn't a priority. Today, and everyday, it is a priority in my home—for me and for my child. Looking back, what I know to be true is that I had plenty of work to do!

There was a day I remember, as clear as the sky is blue, my parents fighting. Being no more than eleven-years-old and just wanting them to stop yelling and screaming, I called 911. *What else could I do?* I was powerless when they got going like that. It happened often.

It also felt a bit hypocritical to grow up in the "church" knowing that no one really knew what happened behind our closed doors—or worse, even on the way to church on Sunday mornings! During most of my elementary years, Dad was gone a lot, working out of town, and Mom was blessed to be able to stay at home, raising all four of us kids. But with those standard gender roles, I also saw what can happen when a man and woman come from a place of brokenness and unspoken expectations from their own, never-healed, childhood wounds.

As a child, you expect your parents to know it all! After all, they are adults. What I now know is that they were just young adults figuring out their lives as they raised us the best way they knew how at that time. But the lack of respect from both parties in the way they treated each other within their marriage was something I saw daily. This did nothing but continue and perpetuate the hurt of their own childhood brokenness. I now realize just how much that impacted me and the decisions I made later in life regarding my own partners and marriage.

Music was one of the ways I knew to change the tone and atmosphere in our home. As things escalated at the end of my parents marriage and my later teen years, I would play worship music. Contention and yelling was standard and a regular occurance. Home was not a place I felt emotionally or mentally safe. So I learned ways to self soothe, and praising God was my way of centering myself. Praying over the dynamics of our home and choosing to believe God was still good in the midst of it all.

As a recovering "people pleaser," and now a mother myself, my number one goal is to make sure that my son spends less time than I have on a therapist's couch due to any hurt and pain I have caused by my own brokenness. It is my job to love and protect him in a way that he feels safe in our home and in my presence. It is my biggest prayer and largest regret that it took me so long to start my journey of self-evaluation and begin to heal my heart and soul. My work is to heal myself so that I am not bleeding on people who didn't cut me. God knew this would be my childhood, and He still had a plan. My story of redemption began in the most vulnerable place possible—*failed family.*

Trust. What a weird concept. But for a child or young adult, trust is standardly given without question. *What is it about trust that becomes hard? Why is it even more difficult to trust the God of the universe who made you?* After making the mistake of trusting the wrong man, it's more understandable what comes after that kind trauma.

Looking back, it was all *so* textbook. I was raised being shielded from much of the secular world. Most of the time we weren't even allowed to watch or listen to standard TV shows or pop music. Mainstream culture didn't regularly enter our home. Because of this, I was never taught that telling a man "no" was an option, or even that it was something to be aware of to begin with.

It was early morning on February 15, 2004. After he left, the first thing I did was take a shower. A person in this mental state just wants to feel clean again! The feeling of dirt and filth under your fingernails; no matter how hard you scrub, it just seems to go deeper. I remember feeling like it was the worst dream I've ever had. A nightmare! *A shower— why? Why do survivors do this?* We want to wash away the memory, and the DNA evidence also goes down the drain with our innocence.

After that shower, I drove home, still a little buzzed. I had never drank hard alcohol before, and he knew that. The smell of Black Velvet is something I still can't stomach. I was only a junior in high school and he was a grown twenty-seven-year-old man.

I had been asked to babysit for a single mom in our church because her boyfriend was taking her away for the night to propose, and she needed someone to stay over to watch her two small kiddos. Our families were friends and I was allowed to have people over after the kids went to bed, per the

parents' approval. I had no idea my entire life was about to change that night. Not only was he a friend of theirs, he was also my youth pastor's best friend. It seemed totally safe.

Next, the rape kit. "This will be a bit cold and you will feel a pinch." How do you process what that even means as a seventeen-year-old, now ex-virgin? When growing up with purity and saving sex till marriage is the *only* option, what do you do when that is no longer the case? When your foundation of family, faith, and your own personal identity, all comes crumbling down within a matter of months, what do you do with that kind of hurt and pain? Who do you turn to when no one feels safe anymore?

How could that be the end of my sexual purity? I didn't even get to give it away—it was taken from me. Maybe this is why I was always attracted to old men after that? Maybe it was the feeling of abandonment from my father leaving to escape his own pain and the reality of looming divorce papers? All I knew was that there was no going back. Why did it matter anymore? I had wanted to save myself for my wedding night, as I was told by the church that was the only way I would be "whole" and "pleasing to my husband." Who would want me now? "No one will believe you anyway. This will just stay between us!" The trust was broken. Trust in men, trust in myself, and trust in God. And so, the plot of my life thickened—*failed purity*.

I was raised with a moral compass and a desire to honor God and do what's biblically right, but my whole life was flipped on its head. So I ran back to my *True North*. The only college application I ever filled out was to a Bible college attached to a megachurch in Portland, Oregon.

I wanted out of the little valley that raised and broke me, to spread my wings and have a fresh start. I wanted to go back to the heart of what I *chose* to believe, even after what I had experienced. I knew I needed God, so without parental prompting, I wrote my essay and prayed this would be my ticket out of this little town.

This megachurch hosted a yearly youth retreat with amazing speakers from all over the world and insane worship music; every year my church from Montana would bus in a group of kids for this event. It was far enough away from home, but close enough to feel like I could make it back for the holidays. It felt like the perfect chance to get my heart and head back on the right track.

However, the sexual brokenness and issue with my spiritual identity went on for many years afterwards, even during my short year at the Bible college. More emotionally unavailable men. More leading with sexuality. More sexual damage. Who was I if I wasn't leading with sex? Sex equals love, doesn't it? So, if I give sex, then will they love me? How many times did I not know that "no" was an option? How many drunken one-night stands happened to drown out the hurt and pain of it all?

If church is not where someone "broken" belongs, then where do you go? This was a heart-wrenching thought after talking to church leadership about my personal struggles. It was not a safe place for me to be honest about the darkest and hurt places of my heart and soul. After being asked by leadership not to return the following year, I couch-surfed for almost two months until school would have ended. Too ashamed to go home neglected and more broke than when I left, how was I going to explain this to my family? Already the black sheep and "mess" by this point, I couldn't even get a full year of Bible college under my belt without feeling like a failure, yet again! What now?

Rejected with my tail between my legs, I went home. Knowing full well that I still didn't want to stay in my childhood-trauma-filled hometown. This was not the place for growth or healing. Too much pain and too many terrible things had happened in this place I called home. Aching to get away from it all, I packed my bags as quickly as I could and worked like a dog to save just enough to make it back to Portland. With no true life direction, no plan other than to not be a victim anymore, I headed back to the big city of Portland—failed faith.

Finally feeling like I could call my own shots, I stumbled into a passion for real estate through property management. It gave me a way to connect my love for sales and for people. Never the same thing day to day there were always new challenges, obstacles, and issues to overcome for the love of giving someone a new home. It was there that I saw a very handsome older man, with two little tow-headed boys running right behind wearing matching Lightning McQueen backpacks. He was a resident and totally off limits. I was nothing short of intrigued. Like a moth to a flame.

I came to find out his name was, well, let's call him Allen. He was a divorced, middle-thirties union worker. He made good money, seemed to be a hard-working single dad with split custody, and was also ten years older than me. It wasn't long until we had our first date, then six months later, a break-up, followed immediately by a shotgun, last-ditch-effort proposal while there were still breakup tears on my face. Who says "yes" to something like that? Sweet girl—man, you should have fought harder to stand up for your self-worth knowing you deserved better!

I really did love him. Hindsight? I may never have been in love with him. But I wanted to be a wife and a mother so badly. So, what's better than an instant family? A six-and three-year-old—SpongeBob, and lots of driving back and forth to their mother's since their dad had odd days off in the middle of the week and they were of school age. Then, seven months later, a wedding. Just what I envisioned, except for right before I walked down the aisle. You know that moment a bride has with just her daddy? He quietly asked me, "Are you sure you want to do this? I will take you to Europe if you choose not to go through with this!"

Was this the way my dad told me, "Daughter, I have reservations? I see red flags? I want something different for you?" My dad was never great with communication, let alone with something so serious and deep. Later, I found out that many people in my life had cause for the same concern. Probably nothing they verbalized would have changed my mind. I was twenty-two at this point, and he was someone who loved me enough to want to make me his wife. That must mean something, right? "Dad, I love him," was my only response. And I did! I loved him deeply.

Just two short months after the wedding night, I felt different. Something was already changing. Could I be pregnant? NO! We just got married. He wasn't super excited about more kids, he even rejected the idea early in our dating period. I thought we would have more time. But, two pregnancy tests later, it was confirmed. We were having a baby! The first thing he did was grab an eighteen-pack of Coors Light and tell me he'd be in the garage; I called my family alone. Every first-time mother's dream. More damage, more hurt, more validation of the failure I felt I was.

I quickly started to realize that my husband not only enjoyed drinking, but may have a drinking problem. Things you don't worry about as a twenty-two-year-old in the bar scene when I was right beside him, taking the shots and closing down the bars after hours of karaoke. One of my favorite pastimes. Now sober and pregnant, it didn't take me long at all to come to the terrifying conclusion that I may be married to an alcoholic. Scared to say the words out loud, as it may make them true, I kept this all to myself. After all, I had removed myself from the church since leaving college and knew that was no longer a safe place for me. I didn't want to worry my family, or worse, have them judge him or me.

"I want to take our son to church." In a conversation I was expecting would be a pretty easy sell, his response was, "If you teach him about God, I'll teach him about Satan." Oh that's right—we had never even had the conversation of how we would raise a child, once we had one. My husband knew I was raised a Christian as well as I knew he was an Atheist. We can respectfully disagree, right? He had his beliefs and I had mine but we never went past that to talk about how we would raise children in our home. Kind of a big conversation to have before marriage? Just a thought!

My husband didn't build the crib, or paint the nursery, or create a baby-register with me. We didn't go to birthing classes or do maternity photos. It just "wasn't his thing." More pain, more hurt, more disappointment. This man was who I chose to do life with? This man was going to be the father of my child? Wishing I had been more healed and chosen better, it was too late—my water broke and the earth crumbled beneath me! I labored for two days before he decided to come to the hospital because he didn't want to miss work! At

least he was there for the birth of our son, Cooper Wayne; "Wayne," named after my maternal grandpa.

"What's wrong with him?" I asked as they placed him on my chest for the first time. Little hands and feet. Ten fingers, ten toes, but no little button nose. What the hell is cleft lip and palate? I had to immediately become an expert on this topic. As soon as I asked the question, he was taken by the nurses for observation. The room went silent. You could have heard a pin drop. And Cooper's dad decided that would be a good time to take a walk because he "needed to clear his head." No worries, I will just lay here being sewed up! Nowhere to go, a million fears and questions, and no supportive husband—failed motherhood.

Cooper needed multiple reconstruction surgeries and the fear sat on my chest like a weighted blanket. Failed motherhood. What if I can't breastfeed? What did I do? Was it that sip of wine? Was it the missed prenatal vitamin two days in a row?

When did my marriage really fall apart? When he showed up to the hospital drunk and half-a-day late as I sat in the hospital room trying to console an infant even the professionals couldn't seem to tame. After hours and hours of whaling and screaming he was finally at peace, sleeping in the crib, when his father came stumbling in, picked him up, and knocked his tiny head on the bar above. The screaming started immediately. "Get OUT," I yelled, and the hospital staff had him removed. I never forgave him. After that day, my heart was no longer in the marriage. The amount of emotional emptiness I felt was something I could not recover from.

With that, it was all I could do to not be emotionally neglected on a daily basis. It was a downward spiral from then on: Never going to bed at the same time. Watching different TV shows in different rooms. Worse than roommates. I always had to initiate intimacy. So I found comfort in the bars, with people who were excited to see me and never forgot to ask me about my day. He would come home from work, and I would leave, not returning until later at night. It really was the epitome of ships passing in the night; we never connected. Unanswered prayers, for years, until I chose to find comfort with another man. Someone who showed me the slightest bit of attention, care, and kindness. Someone who listened and seemed to understand so much of what I was going through. Someone who was not my husband. Yes, we are all the villain in someone's story. I am sure I am the villain in his.

This only deepened his issues with alcohol, to the point of attending in-patient rehabilitation in Tennessee. There is no contact when you go to those places, not for a while. When there finally was contact, he still couldn't get to the point of healing and communication with me. Although we had no money, I chose to fly there for family day, but he was not happy to see me. As other

couples behaved lovingly, thrilled with this opportunity to hug and cry, he chose to take off his wedding band, throw it at me across the table, and tell me to go home and file that paperwork. It was done and, a few years later, I was divorced, a failure again—*failed marriage*.

You would think this would have been a good time for me to get my act together. To get back to my relationship with God and plug back in, as I now didn't have someone telling me no. "That journey of self-growth, healing, and restoration is nothing you will ever regret and is the biggest gift you could ever give yourself, not to mention the people in your life!" At least that's what I, again, was told by my mother.

After my divorce, as many people do, I went sideways, for a year continuing the pattern of sexual brokenness and self-sabotage. In another bar across town, finding a man just as broken and emotionally-desperate as me, I met, let's call him Michael. A self-employed single dad of two, a girl and a boy, aged seven and four. He seemed to hold all the answers. Only looking to be happy and trying to find it within one another, a pattern of love-bombing, gaslighting and all the emotional and mental abuse you can imagine then became my life for four-and-a-half years.

Counseling, toxic fights, church, wild sex, couples devotionals, putting his hands on me and leaving bruises, intimacy conversation cards, shooting our bedroom light out with a gun; you get the picture. This was my normal. It was standard practice in the relationship, and something I desperately believed he—we—could change, eventually. I was *so* in love with this man. I know now that it was nothing but a terrible trauma bond between us, and nothing healthy would have ever come. No amount of love, patience, forgiveness, or overachieving would have changed the way he saw and treated me.

Two different break-ups, move outs, starting my life over. Taking my son in and out of a terrible situation and hoping that maybe, this time, it would be different. It never was, not for long. I called it "dangling the carrot;" just enough change to believe there actually *was* a change. It took me finding out he was active on dating sites, and busting him on a date with another woman, for me to *finally* say, "I deserve better,"—*failed self-worth*.

So, how do you claim your seat at the banquet table rather than accept the crumbs you've been starved on for so many years? Something that has rung so very true in every aspect of my story, other than the reckless love of Jesus Christ in all of this, is the fact that there have been extraordinary women who have come alongside me. I have been so blessed with a strong and gentle sisterhood of women who love me enough to walk with me through it all, speaking truth in love at every turn.

The kind of women who will kick you in the butt and tell you that you're worth more. One who didn't want to hear about the damages of the

relationships I chose and set a personal boundary around that. One who sat on the floor with me and prayed fervently for my children as my mommy-heart was broken after finding porn on their tablets. One who bought me a plane ticket to see their childhood home and shared their memories with me. One who carved out time when I was sick to drop off chicken noodle soup. One who turned into an FBI agent to do all the digging on the new man I met, just to make sure he was worthy of all I am. Women who have watched me walk through the valley and been there to celebrate on the mountain peak. To these women, I cherish you and honor you.

I recognize that not all women are as blessed. Why has that been my experience? Why do some other women struggle so hard for deep and meaningful relationships with other women? My personal answer is that I have always been me. Different versions of me at different seasons, but I have always been just who I am. Without makeup, without apologies, without really caring at the end of the day what others thought. Really not knowing how to be any other way. This is just me. The me God created to be before the world told me who I "should" be.

I have been told I am too much, not enough, full of potential, too loud, unintelligent, damaged, and everything in between. But at my core, I could never seem to morph into what they wanted me to be, regardless of whether that would have changed the way I was treated or how others would perceive me. I'm just me. And the trick? For me to be ok with that—*success!*

I have grown because I stopped watering rocks! Let me explain. The "rocks" are those things that were dead. Things that had no desire to grow or even to be nourished. Things that didn't want to change or see a need for change to begin with. Things that lacked appreciation for the gift that I am, as God has made me—perfectly imperfect.

A very special woman in my church had given me some starter baby plants. After my second split with Michael, I deeply desired living things in my home that I could nurture and take care of. Things that bring me life and show life! "The journey of self-growth, healing, and restoration is nothing you will ever regret and is the biggest gift you could ever give yourself, not to mention the people in your life." I wanted to water something and watch it grow.

They have grown! And I have, too. This involved going to therapy every Wednesday for over two years, serious spiritual accountability, and joining a six-month healing workshop. This took being part of a domestic violence support group with women who knew what I was dealing with. This took choosing me, and to be single for a season to find out who I really was. This took me taking a hard look in the mirror to discover how I was showing up as Cooper's mother. Now, I would not change a *thing*—words I never thought I would say.

In my very first year I have been able to grow a six-figure business as a self-employed licensed property manager. I have made my house a place where I am at peace and enjoy spending time with my family and friends. It's finally a home—my home. I have healed and I am walking in confidence as I date with marriage as the one and only focus. I have a son who is living proof of the changes I have chosen to make in my life and how I show up for him. I have been able to plug into my church and start serving to bless others. I am living the life I could only dream and prayed for just a few years ago.

The hardest thing I have ever done is to take the first step on the road to becoming whole again. There have been times of tremendous pain; the kind that takes my breath away. Times I felt so alone, like I could scream in a crowd and no one would hear me. And even if they did, would they be able to meet me there or even comprehend the hurt? But now, I have come back home, on the most beautiful healing journey for myself, for my son, and for generations to come. My Sweet Friend, it's amazing what happens when you stop watering rock!

Coming Back Home

You think the only people who are people are the people who look and think like you, but if you walk the footsteps of a stranger, you'll learn things you never knew you never knew. You can own the Earth and still all you'll own is Earth until you can paint with all the colors of the wind.

Stephan Schwartz

CHAPTER NINE

Feel It All

Humble Beginnings

I share this for the women who grew up surrounded by people void of emotion. The gray haze of stoicism concealing lineages of trauma, while anyone expressing in full color must be "crazy." Exuberant and silly, I was full of expression until my family told me to "shush" and stop being *too sensitive*. So I zipped my lips and played the part of the "good" girl.

Born in a rural community I had a hundred acres of land to explore as a child, though I mostly stayed on the manicured part of the property with my brother, who is two years younger. We would run freely, talk back to the mama bird protecting its eggs, play with animals in the barn, and eat strawberries off the vine. My personal favorites, though, were coloring and gathering wildflower bouquets for my mom. She wasn't at home much, so when she was I wanted to make it special.

My mom worked hard all her life to prove she was worthy of the same respect as men. Devoting endless hours to the family business to manage the backend (backbone) instead of attending school events, I felt the weight of her exhaustion when she'd get home late at night and still have to cook dinner. Grandma and Grandpa H came from a lineage of farmers and continued the tradition while growing a successful real estate business. Appearances are of utmost importance to my family so I was put on *Weight Watchers* diets by the time I was ten, food-shamed and ate food to fill the gaping hole their judgements blew in my stomach. Food comforted me, until I started my own disordered eating in high school.

My dad was a hard working farmer, often outside fixing something or working the land when we got home from school. In his Mennonite family, men owned and worked the land, women were the backbone of the home. Grandpa C didn't talk much but Grandma C was my favorite, with all-encompassing hugs and eyes mirroring the most beautiful parts of me back to myself. Pure magic. She had a room in the basement with paint-by-numbers and puzzles, taught me piano upstairs, and let me play with the fairies in her backyard garden. She carried the weight of the family— literally and figuratively—yet as a woman, she was not offered the same rewards as men. I was sixteen when she passed due to pancreatic cancer, her legacy living through me, right down to the health of my spleen; both organs represent our

capacity to receive love. Giving love freely to others wasn't the problem, we forgot how to hold onto some for ourselves.

When I dove into inner child healing decades later, I looked into the eyes of my innocence in school photos. It was Grade One when my half smiling face showed suppression from sexual abuse, Grade Three was the fiery shame guarding those experiences. Our bodies are so good at protecting us from what we can't handle that I still don't have all the details, but what I know is that my soul became like a magnet, drawing the same excruciating charge, over and over. Subconsciously.

At age eleven, our babysitters rotated between a few of my older female cousins. Two of them agreed that breasts make you beautiful and shared, "You are so lucky, you'll have big breasts like your mom." I was shocked by their fascination, but was confident I won the beauty lottery—until I realized something was very wrong. One of my breasts could almost fill a B-cup but the other was not much more than a nipple pointed outward like the top of a circus tent. My lack of nurture as a child was evident, a concave empty hole in my chest that could never be filled. I had only known conditional love and longed for approval from everyone. It was not the fault of my parents; this happened over centuries and ran like a virus through family lines.

Object of Affection

In high school, my morning became a two-hour long routine of waking before sunrise, filling the left side of my bra with tissue so I looked normal, then moving to my mom's bright makeup mirror where I would cake foundation on my "ugly" freckles and the red face that might peek through during the day. I curled my hair like popular girls and put on the smiling face I needed for people to like me. Boys started to show interest in me because I was a good friend, but couldn't handle it if I expressed my emotions about the pressures of being female. It was my belief the boys just wanted a showpiece, or a girl who "put out." Maybe if I wasn't as pudgy, they would choose me. I started running for miles every day (hating every second of it) and eating only fruit, as my body became the smallest size it had ever been. I then received the approval of those boys, just as expected.

The rage boiled. I hated men for the world they'd created. I hated boys and how everything was viewed through their eyes. The perception of my own body was filtered through their projections and other women were competition. I internalized what I hated. No matter how much I averted my eyes from billboards, avoided television, and glanced over magazines at checkout counters, tiny-waisted, tanned bodies with big breasts were in every direction. Popular movies, more about sex than plot, filled my mind with

imagery to validate that I would never be enough. String-bikini-clad women started popping up on our home computer because my brother had looked up sites when I wasn't there. The daily assaults to my eyes and psyche had me believing I didn't even fit into the "woman" category. I didn't look like that. It took so much energy to resist, I felt my life force drain, and I no longer wanted any of it. I imagined suicide.

I couldn't find justice anywhere. There were a few friends I opened up to about my feelings of self-hatred, but they said I was pretty and had no reason to complain. One turned into my greatest bully who used my insecurities against me. Isolated and heartbroken, I turned the years of disgust onto myself through self-mutilation. After long days at school, I would lock myself in the washroom and move from scraping hateful words into my skin to crying in the fetal position. I let my mom know that I wanted to die, so she took me to a psychologist. That old man said I had severe depression and prescribed me Prozac, the hardest antidepressant on the market. It wasn't long before I had daily nosebleeds and nausea. My creativity evaporated; I was a gray version of me, masked by drugs. Eventually I stopped cold turkey so I could feel anything again. I never went back to that doctor, instead opting for a therapist who spouted rehearsed lines and sent me home with reading material.

Sometimes the best therapy is simply an honest conversation with another human. Very few people in my circle understood me, so I connected across the globe by writing letters to pen pals and being a part of one of the first ever chat rooms. I think we were all there for the same reason—belonging. I became close friends with a boy in Sweden who said he'd like to move to Canada to marry me, that he didn't want anyone else. I couldn't understand how anyone could love me. Especially with my deformed body. I couldn't accept his proposal.

My senior years were spent at house parties, skipping class, drinking, and taking drugs to escape my perpetual self-hate. My worst night, though, was sober. The youngest person at a party with older cousins, I felt cool; their friend thought I was cute so my family reassured my fearful face saying, "He's a nice guy." He wanted to talk in his truck so I sat in the passenger seat staring blankly at the moon in the dark sky while he made small talk. Had I acted on my intuition, I would have bolted through the door before he locked them and grabbed my arm when I tried to move. I froze, terrified, without enough strength to escape his grip. It felt like my neck was wrapped in duct tape and I couldn't say anything. As his hands went down my pants and he forced himself inside me, I prayed he wouldn't touch my mutated breasts How disturbing that I looked for approval from a monster..

I acted as normal as I could, because if anyone noticed me acting strangely I knew I would crumble back into the million-piece pile on the floor. After a

couple of weeks feeling like all that was left of me was a shell, I shared with my mother what happened to me. She held her breath for a moment, recalling her assault as a teenager and said "It happens to everyone." My words were knocked back down to my stomach from the punch to my jugular.

Soon after, I left home for Art College with crippling anxiety, questioning the choice of my heart as I was told it would never pay my bills. I didn't want to create art for a curriculum either. I wanted to create art for me, not for what other people told me it had to look like. Ironically I wanted my body for me, too, but chose to submit myself to what society told me it had to look like. I met with a plastic surgeon and, once convinced that saline was safe, I pulled out of college and that six thousand dollars was invested in breast implants. To make me feel okay. The pressure to conform is rooted in the construct of our social circles. Have you ever made a decision that didn't feel good, just to please others?

Experience Everything Era

I started redefining myself at nineteen, away from the rural roots that left me feeling unsafe. A city girl with cleavage for the first time, piercings everywhere from nose to belly button, and even a tattoo, it brought confidence to set myself apart. My cousin called me a freak when I showed off my new tongue piercing. Maybe by then he knew his friend assaulted me, or maybe his friend said I wanted it. "It's always the quiet ones you've got to watch," people say. What a paradox to think the quiet one, who wouldn't yell or assert boundaries was a secretive villain.

One part of me was the shy person with a choked throat, and the other part lived in reaction and outrage to the injustice of my trauma—of the collective trauma—until one day it got too much to hold. I proclaimed that I split into two; my body ended at the black wall around my heart. My soul was hidden in a safe place, while I opened up my body for people. My heart was behind that saline wall and scar tissue. The body was all they wanted anyway, right? The pretty face. No one wanted to see my broken bits. If I had a comfortable relationship and sex took the backseat for a while, I told myself they got bored. Devastation of failure set in as I proclaimed they were no longer attracted to me and sabotaged things. Sex, afterall, was all men wanted. They would entertain our late night conversations about deep feelings, but I was sure they were just appeasing me long enough to get in my pants.

I took a break and focused on myself, immersing myself in dancing. There was nothing choreographed about it but, while hiding in my basement apartment, the liberation of spontaneous movements brought me such joy. The side effect was losing weight. *People showered me with compliments, as if I was grossly*

unattractive before. I didn't take it as a compliment, I felt they were insulting my previous form when all forms are worthy of appreciation. In their eyes, the only way to be happy, healthy, and healed was to fit society's ideals.

Looking good does not equate healing, and my body was furious. My chest ached in pain, a puncture-like feeling between the heart and lung that warranted a visit to the doctor. I learned one implant had exploded (ruptured) and the other one was in capsular contracture. What they never told me was that my body was actually protecting me by rejecting foreign invaders—the saline implants. The biggest tragedy is that I wasn't listening to my body because I couldn't. I disowned it from my soul when I split in two. My body was the property of everyone around me and I was sliced open for replacement.

Recovery after surgery saw me being monitored for heart palpitations and getting biopsies on an enlarged lymph node in my neck. My body was screaming that my immune system was overworked and overloaded by the toxins of leaked breast implants. Instead of asking myself if there may be a correlation, I focused on the next distraction. Love.

In my early twenties I enjoyed a couple of reciprocal loving, long-term relationships. The first one, I sabotaged, and the second required us to both heal childhood trauma. I knew I didn't have the capacity or space to help him heal, so I ended the relationship, offering to be friends while he worked with professionals. One day I received a call from an unknown number, to hear his voice on the other end blaming me for his suicidal thoughts. He used keyloggers to read my emails and track my whereabouts. I felt tremendous guilt while living terrified in a perpetual state of fight or flight. I started sleeping with knives under my mattress to calm me enough to sleep, and lived in fear that he was going to climb in my window one night and take his pain out on me.

I moved from place to place, on average once every year, in a search for safety. When roommates displaced me, it forced me to start the process all over again. My time online dating was much the same, moving from one site to the next. This is when I met Noel. I should have listened to my alarm bells when he told me he fought his ex for full custody of his son because she was incapable. I convinced myself he was the best I could get. He hadn't laid hands on me yet, but the verbal abuse was horrendous and when I was just about ready to leave him, we found out I was pregnant. I was elated that it was even possible for me but he offered the ultimate rejection when he said we should have an abortion. *Why couldn't he love something growing in me?* If I kept the baby, he could come after me for full custody as he did his other girlfriend. I was so terrified of that reality that I let him take me to the abortion clinic and hold my smoothie outside as I sat in a dimly lit waiting room of girls in silent mourning. This was one of the most difficult moments of my life. Though

many will say it was my choice, was it really? A life of fighting for my rights as a mother in a skewed judicial system would have ruined me, so I laid alone on the cold bed while they sedated me and suctioned the life out. Within weeks I planned my escape while he was at work, taking my belongings and leaving him a note to open when he got home. *I chose me.*

My life was brighter. I lived in a beautiful location beside the lake in Toronto, working in real estate sales and interior design, and training for my first five kilometer race. I was in a long distance relationship with someone about an hour's drive up North. We were well-matched and happy so he suggested I move up there, to live in a separate apartment. It was insulting to me that, after a long and sincere relationship, he wanted to test the waters instead of going all in. I didn't let him know that it hurt me and, instead, decided he wasn't that into me. I left so he couldn't leave me. The image of his bloodshot, crying eyes seared into my memory and his, "Don't do this," haunted me. Unable to see through the tears, I stopped my car on the side of the road, the nauseous feeling in my stomach due to the realization that I'd sabotaged myself by not speaking.

I also sacrificed my health for appearances. Nothing convinced me to stop spending thousands of dollars on the tanning beds, creams, and sprays that made me look more desirable. I was so tired of being told I was pale that I gave myself skin damage. In one instant our perspective can change, and that happened the day my dad was diagnosed with skin cancer. I'd have to get used to hearing comments about my skin without believing I was ugly, bad, and flawed. Time to act in alignment—no more would I harm my body! But it was too late; I had already caused irreparable damage by making other people's opinions more important than my health.

Then I connected with a woman, both an MD and homeopathic doctor, who said, "If you remove your implants, you'll feel a lot better." My mind rejected her comment at the time, but saved it for later when I could hear without cognitive dissonance. She discovered HPV and I found myself alone on a cold gurney at a Cancer Hospital while a lady with a light on her forehead inspected my uterus. It reminded me of the day I let my first baby go. I let the tears run down my face and wondered, "How did I get here?" My mind was flooded with all those times I looked for love in another person's words or embrace, when I believed my worth was up to them and how well I could satisfy their desires. Somewhere in the searching, I picked up this experience.

I hadn't received the test result for months, so I followed up with the office. I heard, "No news is good news," until the woman on the phone read "severe dysplasia," gasped, and said I needed to come in immediately. *Had I not contacted them, would I have known before it became advanced stage cancer?* Our intuition is always speaking; listening is self-mastery. I had many appointments after this diagnosis to monitor and test. Each one felt as sad

as the first. Eventually a surgery was completed, renewing my fertility. I'm forever grateful to have experienced the wisdom of these two female doctors.

I listened to what my body needed with a supportive life coach, journaling, meditation, regular hot yoga classes, and an encouraging group of female entrepreneurs around me. At this time I was attuned to Reiki, my spiritual sight was opened, and I felt connected to the people I drew to me by reconnecting to my soul.

Then I went back to the professional world to climb the ladder at an architectural firm. I achieved the goal of proving my worth, but the reality of it meant working overtime, feeling uninspired and exhausted in my cubicle while the sun shone brightly outside. I became a workaholic. I liked it that way to avoid feeling the pain of insecurity, and this day I was escaping from the thought of losing a high school friend in a tragic accident. That night red pin pricks moved up my calves and just days later, they turned into large bruises up my thighs. I got to the ER just in time as the platelet count in my blood reached ten; I was given forms for a blood transfusion and the nurses huddled to see this rare spectacle. My body fought itself in an angry rage as my spleen ballooned; a cytokine storm. Life flashed before my eyes. Nothing else mattered; *Here I am laying in a hospital bed alone, again.* Floating in and out of awareness, it was time for a real conversation with God and my higher self—I cried, "What am I even doing with my life?" Just one word. *Family.*

A week later I was released and determined to regain myself. I continued yoga, meditated, used clean food and products, detoxed, started painting and repeated consistent affirmations of health and vitality into my cells. After a long day of fluorescent lights and computer screens, I stood in my washroom asking, "Is this all there is?" I'm so tired. There it was, the glimmer of honesty, the glistening tear on my eyelid, the knowing there is so much more than this. "I love you," I repeated to the face in the bathroom mirror, gazing deeply into my own eyes. It was five minutes but felt like the eternity of all of my experiences in a blip. I faded in and out, my eyes merged with my skin, and all was one, reminding me there is beauty in everything. It's in the soul, not on the surface. I completed my mirror work every day and felt free of the burdens of superficiality. Within a month, my angel of a doctor called me in. Instead of the bad news I was anticipating, she had a gleeful look on her face and told me my platelet count was normal again. She said this could not be done with conventional western medicine and it was my work that got me there. I felt so validated for my commitment, and found myself feeling more proud in that moment than when I achieved my three college diplomas. I had more appreciation for my life—and myself—than ever. I saved me.

I spent every free day immersed in nature. The waters, rocks, and trees of the city were my best friend, holding the writings of my heart as it came alive

again. I discovered a love of cycling and covered the trails. This organically led me to Brent*; he made sure I was all right biking home in the dark with no lights on my bike. *Wow, this is different, I feel safe meeting someone in person while doing something I love.* We spent months of the summer together and in September, the feeling hit me like a wave; I was carrying his baby.

When I told him, it was clear he wanted no involvement and denied that he was even part of the creation. He questioned my sanity and threatened that I couldn't be a good mother. Another rejection of the creative power within me. But I would not disregard this answer to my prayer for a family. This is where I said yes; with all consequences on my shoulders, I Chose Life. And yet his words have bounced between my ears nearly every day—*I'll never achieve my dreams if I have a child.*

The Gift

I left everything in the city to start a new life for us. I bought a "fixer upper," grateful to have somewhere stable to live through maternity leave. During this time, I gained an even deeper appreciation for the healing power of my body for loving me enough to nurture this seed and still have the energy to renovate the house. I knew God had answered my prayer for a family.

It was the ultimate experience to create a masterpiece in my belly. At thirty-two weeks, looking in the mirror as I got ready for work, I heard, "You are beautiful" from my thirty-two-year-old womb. That message was straight from the angel coming earth-side to be my son. No matter how many times people had said those words before, I didn't accept them until the moment it came from inside me. I trusted it and felt the love radiating from his soul, a moment of pure grace I could hold close to me when I felt defeated in the future. And that I did.

Mine was a traumatic birth; twenty-six hours of labor, Pitocin, dangerous levels of epidural, and my voice not being heard. I experienced scars, both from forceps and C-section. In connection circles with other moms, I learned that it's common for women who have experienced previous abuse to have traumatic birth stories; we were taught to be quiet for our safety. Despite that, the instant I met my son I stopped hating men. I felt softness for his father dismissing a relationship with this beautiful soul, because he hadn't healed his own trauma from an absent mother. That didn't stop me from representing myself in court, filing for full custody. I gave Brent every opportunity to be involved, so when he didn't show up I was given the right to make all decisions. While maternity leave was challenging, stretching my capacity in all ways, I fully enjoyed every second with my son. My thirty-third year was the start of a new life. A time to ground presence.

I didn't want caregivers mothering my child, so I started a design company in hopes of better work/life balance. We moved further into the city next to a great school and I rented a (sacred) space at an art studio, happy and excited to fulfill personal goals without relationships as a distraction. As soon as I proclaimed that, there was a synchronistic meeting of who I thought would be my husband. I truly believed I could have it all. The children, the partnership, the dream career—and he fed right into that vision of the future. The trouble was his long-standing addiction to pornography and lying about viewing it while being committed to me. My intense wounds around the objectification of women were opened and oozing everywhere. He saw my rigidity in our most intimate moments, my robotic movements, my reactive responses. We both yearned for heart connection, but I stayed behind my wall of protection. I couldn't compare to the tens of thousands of images he had seen of other peoples bodies, and this consumed me in pain. He was planning to move in, allowed my son to call him "Dad," and soon after, ghosted us with a swift, "I can't do this anymore." My body collapsed and I felt it scattering into pieces on the floor. Again. This time, though, it brought with it a writhing of my heart and soul. Then numbness. I could no longer clarify what was real or imagined, truth or lie, and, most importantly, if anyone really needed me around.

This ending left me feeling so broken that I didn't want to pick up my pieces. Reality was unclear, but one thing was. The cycle of abandoning myself was over; my well was empty and I was the only one who could fill it. Not friends, not men, not family, not work, not coping mechanisms.

Return to Self

The trouble is that if you've experienced heartbreak by your own, or someone else's hands, it will affect your ability to manifest good things. The breaking down of the magnet of your worth, into pellets scattered on the floor. When you pick them up and arrange them in the design of your choosing, you get to manifest your heart's true dreams. *I choose joy and fulfillment*

It took many cycles of "breakthrough/breakdown" before I deeply understood that in order to truly know joy, I had to make room for it by feeling all of the other emotions first.

My son deserved to experience a mother who was in love with life, so I got to work. Children can be our greatest teachers as they mirror what's in their environment. He was the salve for my heart - and - the reflection of the behaviors, beliefs, and projections I no longer wanted.

Before having the reflection of my child, I hadn't witnessed the impact of my actions on others so I leaned in to *feel* past pains without dissociating

from the experience. Decades of repressed feelings came to the forefront so I could feel who I was again; the me who was always WHOLE. It was time to not just look at, but feel the full spectrum of the ways I'd been both a victim perpetuated cycles of hurt by focusing energy towards what I hated. Crying, forgiving, actively moving the emotions out, I yelled while driving in the car or concealed the rage with a pillow. For many days, deep breaths were all the healing work I could manage, as I expelled toxins and decades old grief. I had conversations with my parents; they weren't always pretty but they were truthful and healing. As my reactionary nature learned to take the sacred pause, I sent love and forgiveness to all involved, including myself. I prayed to God in the hard times and in times of deep gratitude. Finally, I felt tears of joy for every little blessing.

I made a mess with palette knives and big brush strokes, layer upon layer as I connected with art again. What I couldn't express in words, I expressed in color, pouring paint like the tears on my cheeks. I wasn't concerned with the fact that my dad said I would never be masterful enough to make a living in art. I just lived through the paint. I let out resentment, guilt, grief and all that I could to create space for what I desired instead. After heartbreaks and setbacks of all kinds, I abstained from seeking my love in another person and channeled that into my love of painting. My spirit cleared all energies that no longer served me as I allowed emotions to move through my hands, outside my body; the freedom of color and movement *cleansed my soul*. I could hear my voice more clearly than ever before.

After some more twists and turns, I found myself back in the place where it all began, on the family farm where the land that knew me since birth could hold me in nature's embrace. I knew it was time to have my breast implants removed. Since feeling everything, I could no longer lie to myself. The truth is not always the easiest path, but I stood my ground as people dismissed me. I demanded that my cosmetic surgeon do what was required—a full capsulectomy with photos. She pulled out my file and showed me the photo of my chest as a teen, "Remember you looked like this, are you sure this is what you want?" Yes, I had never been so sure. When surgery was complete, she shared photos of the scar tissue encasing the implants, my body protecting me from the ruptured implants within. Despite our bodies' best efforts, there are reports of toxins from breast implants in all types of organs, including the brain. The opportunity for true recovery of my body was 9.19.19.

Every previous method of healing couldn't harness the angst of self-loathing that came after surgery, as if I was placed back in time. I don't have a "yoga body," or a "beach body," I have my body and only this one chance to love her. I had been advised to surrender, but it was just a word. To me, surrender meant giving my power away. What I learned was that surrender became a daily devotion to walking in the world differently, with self-awareness and

connection to spirit. When all the crutches were gone, self-love was the act of simply being grateful *to be alive*. When I couldn't look at the shapes in the mirror, I accepted my feelings of being unacceptable in the moment. There are still many difficult days, but when we look beyond the body to the soul, we transcend judgment.

Romance was not a priority & I wasn't sure anyone would allow anyone physically close to me and my scarred breasts again. I finally released needing someone's affection as a reward for what I could do, how I looked or how I could perform. Instead, I accepted being alone, in all the moments of the past and in possible futures. There was space.

Enough space to allow a message from someone I hadn't heard from in over fifteen years. That Swedish boy let me know, twenty-plus years later, he still didn't want anyone else. As we vulnerably shared our stories, I noticed myself invalidate my most damaging experience. "It happens to a lot of people" with a stronghold on my throat. "No," he said abruptly, " It may happen to a lot of people, but I care about you." My soul stood in reverence, unprotected, and I felt that truth.

In that moment it's as if all the women in my lineage were validated for their worthiness to be loved. To be as nature, not asking for approval. Like rainstorms calming the fire, mountains tempering the wind, soil nurturing the trees - so we can breathe. It can feel chaotic and messy and may not look pretty, but it IS beautiful. Wholly.

Holy. As are you. Feel it all.

Let it Flow

Over the next few pages, I will guide you to release stored emotion through creative expression. Gifting myself space to express through my body the words, feelings, and stories that were living inside of me has allowed me to live with more self-compassion, freedom, and play.

As we move through this exercise together, use the journaling pages provided to answer the questions and prompts below. If you do not want to write directly in this book, grab your journal and use it to express your answers onto the paper.

Find a sacred space where you can be with yourself during this exercise. It's important that you clear projections from others, feeling only your emotions. You may get messy, as feelings release through your movement.

This is a process where skills don't matter - it must not be perfect, balanced, realistic, or replicate scenery. Have on hand: paint, paper (think big like bristol board), brushes, magazines, pen scissors, glue, squeegee, sparkles, any other embellishments that call to you.

1. **Begin with Mirror Work**

Stand in front of a mirror, where you can see some of your body but the focus is on your face. Look into the mirror in silence or light music.

Look into your eyes and breathe deeply, in and out in counts of four.

Drop your personality, let everything but the look in your eyes fade.

Look at yourself as if you're meeting a complete stranger. Continue gazing into your soul as you repeat "I love you" as many times as you need until you believe it.

You will feel it in your body, or even cry, when you realize how long you've waited for this moment.

(It could take multiple attempts, but try every day for at least a week and see if it gets easier.)

What did you see?

Who did you see?

What sensations did you feel?

Stay in this space of non-judgement…

Bring forward an experience where you felt unheard or misunderstood, or where someone betrayed you. Maybe you silenced your intuition and voice trying to please others. The first one that comes to mind. Big or small. Remember where you were and visualize yourself in that space.

How do you feel?

If each feeling was a color, what would they be?

If each feeling was a texture, what would they be?

Is there a song you associate with this moment?

(feel free to find some in my playlist at attuned.studio on Spotify)

2. **Get Creative!**

Turn on that song, get tactile and express yourself.

Pull out paint and supplies. Cut out photos. Choose the colors, shapes, textures that you wrote above.

Dance as you create, move your body to the rhythm of the emotions.

With no thought, just feeling, through your art, you can say what you want but didn't at the time.

Big strokes, little strokes, throwing glitter, pouring paint, smearing it all over the page. Whatever you need—color, songs, poetry and the vibrancy of your heart. Make a messy masterpiece.

Let the feelings, the tears, the shudders, the rage, escape your body. Move your body in the way it's asking to be moved. Spin between brush strokes. Crawl and stretch on the floor!

3. **Shake It Out**

To complete the exercise, shake out the feelings that may still be stuck.

Wipe your body as if taking a cloth over it from the top of your head, down your neck, around your torso and down your legs, through your feet into the ground.

Ask that all negative energy be transmuted through the earth and visualize a healing white light above your head that cascades through your body and into the soil.

When you feel clear, it is complete. You are free.

Repeat with any other experiences you haven't been able to out-think.

Allow space for all the joy, health, peace, and fulfillment you can hold. Be blessed by the mess!

Let it Flow

Look deep into nature and you will understand everything better

CHAPTER TEN

Roaming Hearts and Wandering Feet

[SHE]

Deep down inside the depths of SHE
A wisdom longs to be unearthed
Twisting and turning SHE feels the yearning.
Whilst nourishing and grounding eternal is
BIRTHED

The universal light moves within SHE
A birthright engraved in the souls of all.
Weaving and creating, vibrations are felt.
With knowledge and insight, SHE hears the
CALL

Flying feathers amongst wings enveloping SHE
Like a bird soars to such height
Awakening visions attuned to soul's creator
Feeling all within
Flowing without
ILLUMINATING SO BRIGHT

Together, We Become Whole

To "Become Whole Again" is to strip down naked to the bone, peeling away the layers to reveal all, and the ideals of the sense of I. Reaching the core, delving in and seamlessly transitioning.

Somewhere along the spirited path shines a guiding light, an opportunity of redirection within purpose to sink back in and re-focus with a new set of wise eyes, to look around at textured facets buried deep within the body's essence.

There's no skimming the pages like the first exploration.

This is a reopening, reliving, and revisiting of the wounds. Moving to the very brink of where the mind's capacity may reach, while awakening and inevitably healing.

This is where you have your *Rebirth*

What started out as an amazing opportunity to share life's past experiences with other human beings, within the writing of pages to visit the wide world, ignited a new journey unlike any path I had walked before.

Shared here are insights and inner knowledge gained along the way.

It is my hope that this chapter resonates deep within you, the reader.

May this initiate a witnessing view of your life path from a perspective of "outside looking in" to see how you too may have been impacted by similarities shared within this story.

May we share open communication with our daughters and not be held back by our own mothers' suppressed emotional states.

Let's break past the generational hindrance, hurt, and heartache tied together.

> *"Embodying all the knowledge learnt within the transition from childhood to motherhood and becoming the maiden. She shared wisdom through her heart to the ears and eyes of those near and far. The misunderstood, misfits, and rebels of the world who were too afraid to be themselves, to learn to believe in who they really are inside. The once-ebbing light now shines ever so bright; here they acknowledge the true essence inside and speak wisdom to their tribe, inevitably having a flow effect throughout the lineage to come."*
> ~ Tammy Ann Taylor ~

Where It All Began

Looking back through time and into the present, I noticed how many of my life's pathways were a direct triggered response to those who were around me, especially when it came to body image and, ultimately, my sense of worth. Almost one hundred percent of the time these were influenced by the words and energies of other people, as well as external sources.

Not only that, but indeed a huge percentage of my life was impacted by others surrounding me. In many other ways, I was an open book. How would I have lived a true life for myself in authenticity if I had really known the *true essence* of my being.

Perhaps if I had been given guidance to find and acknowledge my true identity, to even be encouraged to be myself, I may not have lived in this place of time like a sea mollusc sucking up all the toxic surroundings of my habitat.

Relationships past and present were, in fact, highlighted—including those with my parents, past intimate lovers, friendships, the relationship I share

with my daughter and, ultimately, my marriage. I gained insights on how we all are as individuals, and how our lives are impacted by all influences, and that if we all acknowledge and connect to our true selves, the "soul," we would instinctively have the tools to shine without fear.

Quite possibly, we as a collective would emanate higher vibrations within love and connection to each other.

My lifelong bucket list of "anything goes as long as I've never experienced it before" includes hiking in the Southwest of Western Australia. During the wintery month of June 2023, I embarked on this bucket list expedition with my family in tow.

As a child I was wild and free. With an undeniable hunger for adventure and filled with heart-bursting adrenaline, I spent my childhood raised in a small country town—barefoot, running wild in paddocks brimming with flora and fauna, and racing motorbikes. Putting myself out there to try adventurous things is nothing new to me.

Hiking challenges me mentally and physically, in turn pushing me out of my comfort zone. And while I am a yoga teacher, this requires a different type of fitness. Unlike my strolls on the beach, easily being whisked away by the wonders of nature, hiking stretches me even further due to my health issues and autoimmune diseases, which are unfortunate side effects from one of my pursuits for beauty perfection—but that's for later in this story.

Given we had three days of escaping the daily grind, it was decided that we set a goal to accomplish three hikes in three days. Always up for a challenge, I knew this would be a pivotal point in my life's journey.

Packing for the climbs ahead with my eleven-year-old daughter, I reflected on how this venture mirrored life. If only we all, with the guidance of our mothers, could pack our backpacks to include everything we need to ensure a safe arrival.

Wandering Feet

During our second hike, the most testing and gruelling with rough climate, gale force winds, and rain, I found myself moving through fears and doubt as I ascended the heights. Then at the top, one hell of a reward awaited us; the most magnificent view I may only see once in a lifetime.

Taking huge risks in the blustering wind and rain and looking up, deep into that ancient monstrous rock crevice, made me feel so alive. I'm sure there were warning signs placed within sight to discourage too much exploration (due to the chance of rock falls), but somehow, my mind kept aching for more. *I worked so bloody hard to get up there, why not take an extra risk?* What a rush! Nothing in the world comes close to feeling that connection to your body where your heart pounds out of your chest and you're living on the edge.

If you don't push yourself through limitations and challenges, reaching out of the comfort zone, the beauty of the path traveled may never unfold.

The third hike on the last blisteringly cold, toe-numbing day is where the enraptured magic really took place. Originally I wanted to see the sunrise from the top, but there's no way that scale can be done in the darkness of an early, frosty morning, even with a head torch. It would be insane.

We decided that we all ached to see snow, although it wasn't to be. But at the time we had a mission to conquer. Elegantly warm and looking like complete goofballs, we set off to embark on our adventure, leaving for our climb at around nine in the morning. This place has a mystical and energetic rawness. With so much beauty to be absorbed, a stunning waterfall protrudes out of a rock crevice, crystal pebbles shimmer in the rays of the morning sun, and the greenery of plant life glistens with sensational color.

Each turn and height reached revealed its own scenic vision. It was its own unique path; just as the path of life unfolds, this path moved within different terrains—some rough, some smooth, some difficult, and some with an easier motion forward. One step at a time we were offered beauty where each individual could choose to see it through the depth of where our minds could take us while ascending.

Halfway up, my daughter, Ellyssa, was not overly happy; her internal voice becoming the external words, "I don't want to do this, I don't want to be here." Instead of talking myself mentally through the mind games of brain versus body, I decided to use the opportunity to encourage her to keep going. I determined to use this experience as a mentoring for her path of life ahead. Lo and behold, I was presented with a distraction for my mind's inner torment. (How convenient and so forward thinking, smashing my mother-role right?)

My inner voice spoke with insight only the natural world can help provide,"When you're in difficult times, or feel you can't complete things, or even keep going because life is tough, visualise, take yourself back to this point in your life, here with me by your side. With every step you take, you accomplish. Even when it seems so very difficult, remember what you did when you thought you couldn't do it."

Greatest View, Insightful Lessons, and Conversations with our Daughters

Have I died and gone to heaven? Are my eyes deceiving me? This seriously is the most magnificent and majestical sight I have ever seen.

Who the hell was I kidding? During the last half of the hike up, we couldn't see the view around or down due to the heavy fog only the joys of winter offer; at times we had only shattered glimpses of the path ahead. Of course, I couldn't see anything below a few meters of the face of the mountain, down into the depths of the abyss.

Where's my reward for all the hard work? Typical! But at least it makes for a good story.

I must admit, I did move myself to the riskiest of textured landscape at the top—on hands and knees, nonetheless. I wanted a real sense of the depth perception that I was missing through human eyes, and if it hadn't been for the feeling of safety amongst the pillow clouds I may not have ventured that far in seeing the real vastness of our actual surroundings.

But this venture was much more than the view.

Deciding to share a little of my past with Ellyssa, she was open-hearted, kind, and caring in her responses, which were mixed with a maturity beyond her years. I believe she was thankful for me to truly share my innermost self. In explaining that I had never wanted her young shoulders to be heavy in the burden of carrying her mother's hurt and past mistakes, a realization hit me. What I share in this moment could change her life's direction, in turn hopefully opening a mother-and-daughter channel for communication, and create the possibility of healing and for generational curses to be lifted. I ponder that I had never experienced a close mother-daughter bond with my own mother. *Maybe I am carrying too much resentment?* Unbeknownst to me, the key to my past was sharing my heart with my own flesh and blood.

Amongst revelations, I drifted to distant memories.

<p style="text-align:center">***</p>

The pungent smell of stale cigarette smoke fills the air while I visualize my mother.

Conversations about my birth, how she struggled to connect with me, and may have suffered from postnatal depression (undiagnosed and unrecognized in the 1980s). I was the first child born into a family feeling the pressure to have a son to carry on the family name—a burden also carried on the father of

my father's shoulders, my "pop." Inevitably, I became a "tomboy," my dad's first boy.

Upon reflection, this may have been the start to my fracturing mind and disconnect to my body.

I remember my mother's own struggles with self-identity, body image, and mental health illnesses throughout her life. Ashamed by her looks, never allowing her face to be photographed, and sometimes a little over-obsessive with the number on the scales, my mother was a beautiful, slim woman—but she never saw that.

A woman with a scathing tongue that, at times, could cut you like a knife, she lacked the communication and healthy, affectionate mothering skills to fully guide her daughter. Her daughter who deeply desired the heart connection she had been deprived of since the day of her birth. Later in life, through spiritual insights, I came to view and understand that my mother's unhealed childhood trauma—kept heavily guarded under lock and key and buried in family secrets—became the building blocks for her life path. Looking back, I acknowledge the impact my mother had on my lack of self-worth. This, of course, not being any fault of hers.

Amongst the aura within this memory of my mother, I recall my first episode of body dysmorphia at the blossoming age of fifteen, spurred on by a family move from country to city and my father telling me I had a "fat ass." My dad, a jovial man, may not have meant what he said, but my young heart was always so impressionable. My father also had a lasting impact on my need to try to appease a man's wants and needs; this, mixed with cries for affection, was not a great combination for a woman in this world. This turning point also included other choice words from masculine energies that ultimately impacted my state of mind.

I recall a moment of opening the fridge upon hearing the words that I needed to eat before leaving the house. Looking at my mother with contempt while rummaging for two plums in haste, I cunningly debated eating one right there in front of her while the other plum probably had a date with the ground on the walk to my friend's house. Within a young, fracturing mind, I felt that the pieces of "vile" food may not only ruin my plans, they may also derail my Tam-train in motion within self-control. Every miniscule bite was like eating poison.

In that moment, I decided the plum couldn't stay in my stomach because it would make me pile on the weight and, unfortunately, I would want to eat again. I felt I may not have been able to starve myself anymore. Having an epiphany, "I can purge it out," my teenage mind went into panic mode, "How the hell do I stick my fingers down my throat and vomit?" I despised the

feeling of vomiting; I'd wince and whimper at the mere thought of swallowing paracetamol tablets.

It's so difficult to regurgitate next to nothing on an empty stomach. Somehow I accomplished it, and from that moment, I inevitably entered a new phase of control over my life and my body. Or so I thought.

This was a pivotal time in my existence, with eating disorders showing up many times throughout the coming years. Unfortunately, I was always terribly disconnected from my body and my mind was my own worst enemy. In hindsight, maybe a conversation between mother and daughter may have set the wheels in motion, heading me in another direction

"Mum I'm struggling with my identity; I don't know who I am or who I'm supposed to be." The echoes of Ellyssa's voice re-focuses me, bringing me back to our immediate reality. I hope to guide her with a set of self-inquiry questions and some suggestions for her to be her true self and to do what makes her happy, not what she thinks she needs to do for others. We spend minutes together immersed in thought process.

After some time, I look at her and say, "What makes you happy, Sweety?" With heart wide open and her beautiful brown eyes staring back at me, she replies, "You do, Mum." A stunning moment wrapped in time brings us to embrace; neither of us will ever forget that momentous hug.

I feel it is time to be open to her about one of the biggest mistakes of my life, setting aside my fears that she may feel enhancing her looks is something she should internalize after learning her mother went in that direction. The mere absurdity of putting plastic in my breasts to make them appear larger and perkier in my somewhat "reach" for societal perfection seems ludicrous when being relayed to an eleven-year-old. *What will she think of her mother, the one who is supposed to guide her to be an authentic version of her true self?*

Amongst this space it is time for Ellyssa to hear about my past life experiences with lack of "Identity." So I share how breast implants caused my body to have an autoimmune response that made me very sick. Hundreds and thousands of women across the globe have also endured injuries by these devices, and continue to be hurt to this very day. I share with my daughter how my experience, in turn, directed my life to become a spokeswoman for the women without a voice, and that I shared my story far and wide. I tell her that I also stepped out of comfort zones, speaking publicly throughout media outlets, and inevitably starting a support page for Breast Implant Illness to bring women together in a wonderful and supportive community. All to help

bring awareness to other suffering women to help prevent them from traveling the same painful pathway.

How did I change the story from sorrow to triumph? It's all in the mindset, And relaying the past to my offspring helped me sense the "bigger picture." It is, after all, about the "view."

If we had not embarked on such a journey together, would we have shared our mutual insights on self-identity? I believe the universe put us both there, together at that time, while she was experiencing similarities to my life all those years ago.

Have I ensured that her arrival to womanhood and her life path ahead will be different from the footprints she may travel within her mother's shadow? Only time will tell.

Although it was a vulnerable position for the both of us to be in, we ultimately connected like all mothers and daughters should—in non-judgment, whole heartedly within communication, empathy, love, and emotional support.

The View from Below

In contemplation amongst the Southwest countryside scenery, with the heavy fog lifted we both observe our surroundings with a triumphant spirit, reveling in connection and the strength of our newfound bond. Held in the safety of Mother Nature's arms, this is a breathtaking backdrop for an outpouring of two souls through an openness of expression, without the confines of society or the limitations we may have lugged on our shoulders on the way up the mountainside.

I revel in contentment that my body conquered the mission, although failing at times over the years, and having quite a few stops to check my blood levels and rest my racing heart and achy limbs. I made it—rising, and slaying doubt.

Feeling like an unstoppable force of nature, I now have a newfound sense of awareness and purpose.

Yogic Journey

During the years following my breast implant surgery, I birthed my second child, Ellyssa, and started to get into running. I had decided it was time to get healthy and fit as fuck; it was my time to truly connect with my body.

I started running on my treadmill (affectionately named "Trevor") with a goal of running forty kilometers a week, and somehow I achieved that with determination and a new healthy mindset. At the age of thirty-two, I felt my life had finally come together.

It was one of those nights, where sleep does not want to visit, that I found myself within a state of meditation. This was something I had not experienced prior. Instead of crawling out of bed in a sleepless stupor in the morning, I bounded out of bed with energy and a vibrancy for life; I had received a calling to become a yoga teacher.

As soon as I needed my body to perform, it literally started to fall apart. Instead of taking one year to complete my yoga teacher training certification, it took two years due to serious illness. I would wake with such fatigue it felt as though I hadn't slept the night before, and boy, did those heavy black bags under red bloodshot eyes tell a story! Lightning bolt pains intermittently shot through my spinal cord, jolting me where I stood, while brain fog, and plantar fascia burning sensations radiated from my back, directly behind my implants. Swollen lymph nodes, tinnitus, extreme hair loss, and nerve and muscle pain had me crawling out of bed like a ninety-year-old, close to death's door. I felt as though my body had been taken over by an alien that controlled all aspects of my endocrine system and brain functioning. I slept—literally—for days on end.

In the second year of my training, I was blessed to fall pregnant with my third, and last, child. This pregnancy had me feeling healed from all ailments; although being diagnosed with gestational diabetes and having to use insulin, I felt the healthiest I had in three years.

The sense of peace that came over me within yoga practice and training was one of the most profound spiritual awakenings I've had in my life. Although, somewhere in the back of my mind, I felt as if an alien still inhabited my body and I feared it would come back with a vengeance.

In hospital, a day after having Jed, I received my certificate via email. It was sent by my yoga teacher, Monica, a wonderful woman I still look up to as a divine mother figure. Such a special and momentous time in life; a beautiful gift of a baby boy and a new path following my heart.

Within months of his birth, after the pregnancy hormones had subsided, I became ravaged by the succubus and riddled with even more symptoms. Another new lease on life smashed to smithereens.

After years of investigations, including surgeries and taking Lyrica for nerve pain, I was finally led to discover the cause of my body's inhabitant—the "alien" was indeed the man-made foreign objects of breast implants, the "poison bags."

Poison Bags

I take you back to a moment in time when I recall waking from the breast implant operation. Only weeks before having a dream that I died on the operating table, I had hastily decided to change surgeons at the last minute. (How I view that prophecy now and see the warning I chose to ignore.)

The vision of myself looking around with hazy eyes as an equally anesthetic-hazy mind lurched forward, tilting to the side of the hospital bed, regurgitating that chemical-tasting substance. I look down counting one… two.. new "lady lumps." Where once, my firstborn suckled the life out of my breasts leaving two saggy, sad sacks of skin. The tomboy child who hated the pubescent transition in growing breasts now had sexy bazookas, (ahhh, the irony). I found I now had some self-confidence.

Never in my wildest dreams did I think the expensive new assets would gift me with two autoimmune diseases, including Coeliac Disease, and Type 1 Diabetes, and a bill of eighteen thousand dollars to take them out, including a lift to repair the saggy skin to boot! Not to mention all those days sick from work and tonnes of money spent on trying to make myself healthy.

Echoes from a Soul who Felt So Alone

When the mind begins to wander in self-inquiry, I find myself deep in the seat of despair. Here I am on the outside looking in: She's crying (it's me), "It takes more than a few goddamn massive knocks to knock this one down and out. Years, in fact, of symptoms, and a long list of terrible illnesses. Three long years in fact."

Looking at the doctor in disbelief, and then over to my fiancé (although he looks at me with tenderness in his eyes), I can't help feeling that both he and the doctor think I'm a hypochondriac, and possibly insane. Maybe the next stop is to be directly admitted to the mental hospital my mother resided in a few times?

All the blood tests, scans, investigative surgeries have—what? Equated to nothing! Years of pain and unexplained debilitating symptoms. I was going to crack; I felt I was better off dead. I felt unheard and that no one believed me, and for that moment in time, I wasn't sure if I could survive. Not only did I feel I was better off dead, I felt I was dying anyway. Once I walked out of the doctor's surgery, I brushed myself off and shook the "emo-feelings" out of my head.

I knew I had to find my own way through this, and possibly find another doctor. I knew I wasn't insane!

In the end, the medical industry did not direct me to the root of the problem, my sister-in-law did! She dropped the words "Breast Implant Illness" and reading through the symptoms, I pretty much ticked them all. It's a long list just to have perfect tits. And if I knew what I know now, had I been informed by the "professionals" in whose hands we put our lives, there's absolutely no way in hell I would have undergone such a surgery.

After having the implants removed from my weak and failing body, I gained so much insight. This included that a healthy body and the ability to live a full life were way more important than looks. My mindset ultimately had to change with such an experience. I have scars on the outside to prove it, although nothing compared to the damage that goes unseen on the inside. Having autoimmune diseases almost guarantees years off a life that should have been long lived in a healthy state. The scars remind me of the internal battle my mind and body faced in all those years of disconnectedness.

Everyday living with two autoimmune diseases really shows how strong I am.

From the Ebb to the Flow

I now live with a hunger for life, drawing light from the days I couldn't move due to the fatigue in my once illness-stricken vessel. While there are days, sometimes, where I still endure exhaustion, within this space I sit in waiting, listening to my intuition. I connect to nature and ponder on adventures to come. How and where I may put this beautiful body and vivacious mind to its test.

I believe this is the gift I have been given.

Having been on the biggest ride of my life this year, (yes I did say I loved adventure), the sense of self—of who I really am—woke up. "Wooooooooof," she's a wild vortex of a woman. Trust me there's shit-tonnes of creative flare, and fire in my belly.

I'm now a poet, published author (both writing, and poetry were a huge part of my adolescence), and I'm soon to be a facilitator for Creative Heart's ™ yoga, meditation, and arts workshops.

I've let go of the need to appease others and the thoughts of what others opinions are of what I do or how I look. After all, it is my life—fuck what others think, may they lay judgement on themselves before judging another. There's no way this creative deserves to be placed within a box, and nor should you!

Take time to nourish your soul, heal, and move back to the roots of your happiness and desires. You may find this by revisiting ideas and activities that sparked your flame as a child or adolescent. Start by getting back to nature and peel away any constraints you put on yourself or that of others. Your relationships may dissipate in doing so, but some may grow. Ultimately, the relationship with yourself is the one that deserves to be truly taken care of.

> Unapologetically me, I live fierce, unafraid, and untamed. An adventurous soul, shining wonder in my eyes and a light ethereal body only the true can see.

Collectively within these words, amongst these pages nestled and entwined in this chapter, a warrior woman was born. And together with the tribe of warrior women breathing truth throughout this book, we speak our wisdom through lessons learned. We are here alongside your inner warrior woman. We are the voice inside of you; together with the tribe surrounding you, we all weave magic throughout the world and for the daughters and women to come after us. We all are one, we are of one voice, together—we rise.

Reconnect with You

By being back in sync with the natural world we become renewed, reconnected, and rejuvenated. Feeling more alive and ready to conquer anything life has to offer you.

Nature has forever offered healing to me in some of my most challenging times; my desire for you to reconnect to you by immersing yourself back into nature.

Start here

Head to the ocean and take a meditative walk (without your headphones), taking in the sights, sounds and smells. Don't forget to bring your journal.

When your body feels calm from the walk, move into the water because the salt water offers deep cleansing. If you can, allow yourself to float and slow your breathing

Float for as long or as little as you want. It's all in your flow.

Once out of your cleansing bath, it is time to open your heart and chest to the sun.

Directly point your body in that direction, and stretch your arms out wide.

Lay in the sun and soak in her warmth.

Take out your journal, or use the blank pages following this exercise to explore the below

1. *Call in your Inner Child:* What did you like to do as a child? Where were you at your happiest, e.g., painting, with animals, at the beach, writing, dancing, creating, or other activities? Write freely on what comes to your mind.

2. *Your Bucket List:* Plan for some soulful experiences that you know you have been waiting for the right time to do one day. Write down 50 things on that list and leave the beach with one locked in your diary!

3. Create your Life-mantra: Writing and letting yourself express creatively offers healing. I personally love to create life-mantras that resonate for the season I am in. Perhaps, this will resonate with you too. Write freely and notice themes that come up, then turn that theme into a positive self-affirming mantra!

Affirmations I personally use and have created:

Nature is the gift we are given and the key to learn about our true selves.

I am connected to all above, below, within, and without. Guided by my heart desires, I manifest my hopes and dreams by speaking my truth and honoring myself.

I am at peace here. I breathe in all the beauty and breathe out all that does not serve me.

I embody a sense of awareness and purpose, I am an unstoppable force of nature.

Have fun playing on the following blank pages!

The beauty of a village is in its soul, its spirit, and its heart.

Meet the Village of Authors behind

BECOMING WHOLE AGAIN

Shannon Rose
Author of: **Love Hurts. A Pilgrimage of Coming Home.**

With a big breath and a leap, this book is now complete.

I pray that this book in and of itself is the expression of wholeness, where every woman who has had the bravery to ink their pens alongside me has contributed to the creation of exactly that, for YOU.

The book that you hold in your hand was always destined to begin a Movement. In keeping with one of my greatest values, which is that we are nature, we came from our great mother and to her we will return. 'Sacred Daughters' is a grassroots movement born from the ground on which you stand, to cultivate remembrance within the women of today, for a sacred and connected tomorrow: *for our daughters.*

Becoming Whole Again is an expression of who we were before all the stories, before shame entered our body and stole the voice from within our throats. Healing yourself naturally asks for your voice to be liberated; let this be your permission slip to write or speak your heart out.

My work in the world offers a safe place for women, just like you, to land softly and intentionally to begin unraveling all that was never yours to begin with. Life is here to be lived, not pushed uphill until your last breath. Come home to your body, learn how to listen to the whispers that move from within and let your body be your greatest mentor.

As a survivor of trauma myself, as a Mentor for Survivors of Human Sex Trafficking, I have learnt a lot and I have a lot to learn. I have a keen interest in understanding developmental trauma and breaking the chains of shame and pain around the ankles of women globally.

Connect with Shannon on a deeper level:

IG: @iam.shannonrose

www.becomingwholeagain.com.au

Jennifer Robertson

Author of: **If This Body Could Talk, It Would Tell An Amazing Story**

Showing up in the world as our true self takes so much bravery and strength. We crave love and acceptance, so we morph ourselves into someone we think is lovable. Our pretending leads to small parts of us slowly breaking off and being worn down over time, until we don't recognise who we have become.

Becoming whole is about learning to put those pieces back together, and having the confidence and strength to live as our true selves again.

And that is why I said YES to this project. Because I was sick of pretending and being at war with my body. I was exhausted from carrying around baggage that was never mine to carry. I was scared of passing down generational trauma and unhealthy beliefs and behaviors to my children. But most importantly, I was ready to release the control I was so tightly holding on to, and find freedom and power in who I am.

And that is my wish for you too. I want to light that fire in your belly, so you can break those chains that have been restricting you from living the life you were meant to live. I want you to realize that you are already incredible, and worthy of receiving love. I want you to find beauty in your perceived imperfections. Because that is what makes you unique. And you are more powerful and free being yourself than anyone else.

My work in the world is to speak my truth, so others have the courage to do the same. To teach those around me, how to embrace the light and the dark within us with self-compassion. And to encourage them to move through life, carrying only that which belongs to us.

Connect with Jen on a deeper level:

IG @msjenniferrobertson

www.jenniferrobertson.co/connect

Amy Nava
Author of: **Healing To Be Seen**

The messages I've heard and felt all of these years have connected me deeply with my soul.

Listening to the inner whispers and leaning into faith nurtured my growth. Crystals elevated my vibration and sparked my creativity to make Mala. Utilizing a Mala with mantra helped strengthen my meditation practice, and this brought miracles into my life. Now the impact of self-healing ripples out and lights the hearts of others to look deeper.

The gift of knowing who you are and trusting your unique expression is unmeasurable. This is how we rise up, out of the hardship of abuse, addiction, and old patterning that holds generations back.

My hope is for you to feel inspired to walk in faith, knowing that the roadmap to your life is already within you. The whispers are there for you, maybe it's time to meditate!

NAVA Mala is my creative gift to the world. Crafting intentional gemstone mala and jewelry for meditation and manifestation.

"Stand in your creativity and passion. Never be afraid to heal."

Connect with Amy Nava on a deeper level:

IG: @amydnava

www.navamala.com

Amanda Rumohr
Author of: **Dear Daughter, Dear Self**

Somewhere along the way, our authenticity becomes buried as we keep up with a fast-paced culture of high stimulation and distraction, and the pressures of success and expectation that were never our own. Self-betrayal eventually compounds into self-doubt and lost connection with ourselves. In this way, I believe that becoming whole begins with our unbecoming. An unraveling, a process of refinement, and stripping away that which was never authentic.

I have always felt called to this work, and furthermore, the creation of a family culture to serve as a foundation for my daughters. I believe that the path to generational wellness and a strong family culture begins with the heartbeat of the home; the mother.

Motherhood served as a catalyst for the unraveling of all that was not me, and inspired the use and trust of my voice and intuition. By sharing my story, my desire is for you to unravel into your wholeness too. My hope is that my words inspire you to question the corners of motherhood and life that do not bring nourishment, and explore the ways your heart longs to be fed. In doing so, my hope is that alongside one another, we courageously create life and lead our family from the embodiment of a satiated heart.

Our work in the world is ever evolving, but the most impactful work will always take place within the four walls of our homes. Should you wish to explore a reconnection to the wisdom within, and unravel into the wholeness of your heart, my door is open.

Connect with Amanda Rumohr on a deeper level:

IG @amanda.rumohr

rumohr.amanda@gmail.com

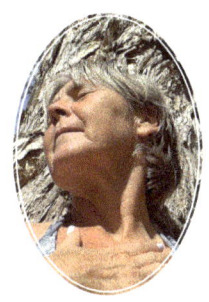

Ruth Johnstone
Author of: **Walking my Inner Child Home**

When I said YES to bring my voice forth, I had no idea how my life would change, but as I look within now, my body feels so much lighter (not physical) and freer, my heart is open and I have so much love for myself as well as for others.

Sharing my story has been such a powerful healing practice, as I wrote and spoke about my own experiences of what happened inside of me, which then allowed healing to enter as trauma was leaving. Now that it is done, the energy has shifted and the burden has become lighter, transmuting and transforming those frequencies back to source, while creating a beautiful space for peace and love to take up residence in my heart.

Saying YES to myself, showing up in my rawness, vulnerability, and authenticity, while holding my inner child as we walk each other home.

Wholeness means showing up for myself with all the broken pieces, by slowly releasing through movement and stillness, sitting with myself without judgment while accepting every dissolving attachment. Wholeness encompasses all areas: physical, mental, emotional, and spiritual. My daily Yoga practice has given me the space to listen to the whispers of my body, heart, and soul, leaning in deeply while feeling the uncomfortableness, because it's where the biggest messages and healing have arisen from.

My biggest gift for you, my reader, is that you take that leap, look fear straight into the eyes, but say YES to yourself anyway by trusting in a higher power that will lead you and allow you to become whole again.

My gift to this world consists of facilitating a process where my clients can reconnect to Spirit as I work with subtle energies, creating conditions that allow healing to come through.

Connect with Ruth Johnstone on a deeper level:

Facebook: Ruth Johnstone

www.heavenlygoodnesswellness.com

Katie Storm
Author of: **Your Worth Is Not Defined By The Weight Of Your Body**

One of God's greatest gifts is wisdom, and wisdom comes from experience. Through uncomfortable and painful times, our traumas deliver us to our healing and we are gifted an opportunity and a voice to share our story. We are not broken, we are built. Built with a purpose to share whispers of hope.

Becoming whole again is about the journey, not a destination. It is my prayer that through parts of my story and this book, you will feel less alone. That you, too, will start to hear the whispers of hope. I pray those whispers spark a feeling of worthiness inside you. I pray that you feel encouraged to speak, to establish boundaries, and start to love all of who you are in this moment and every season to come.

You are worthy. You are special. You are valuable. You are beautiful. Just as you are.
You matter. Your story matters.

"A woman who heals herself, heals her mother, heals her daughter, and heals every woman around her" ~unknown

It is my gift to the world to be me; the me that is brave enough to use her voice. As a leader, daughter, mother, sister, friend, entrepreneur, and as a stranger, it is my honor to be a woman who moves forward in grace with intention to connect through faith, hope, and inspiration on my forever journey of healing.

Connect with Katie on a deeper level:

IG: @katiemariestorm

Linktr.ee/katestorm

Lindsay Hart
Author of: **Coming Back Home**

Becoming whole again was not a choice for me. In this chapter of my life, I had come to the end of myself and what was no longer serving me. I had to go deeper. I needed to start the healing, regardless of being terrified! To join a community of other women who were just as hungry to change, grow, and heal was a blessing; it made me feel more secure and safe to do this with like-minded and courageous women.

As a single mom, my property management company and son keep me very busy. I am thankful to live and work in the Flathead Valley and raise my son here, out of the busy city! Cooper and I enjoy anything regarding the water. You will find us boating, tubing, kayaking, and swimming most of the summer. Cooper turned thirteen this year and is actively involved in the church worship team, as well as every sport imaginable. I am also active in my church and am working on my physical fitness and overall well-being.

I am honored to be part of this movement to share our stories, to use our voices to encourage other women to be brave and become whole again as well. To show up in their lives the way they want to and be the women they were always called and made to be!

Connect with Lindsay on a deeper level:

Facebook: lindsay.ruggles

www.truenorthmanagementmt.com

Bracken Rae
Author of: **Transcendence**

There is medicine in the telling of our stories.

The healing reaches far and high, like the branches of a tree, to be activated in the hearts of those who read it. I experience the world through a multidimensional lens; many senses wide open, seeing past lives, angels, guides, light beings, and the frequency behind manifestation.

Being an Intuitive Channel, Healer, and Spiritual Coach, there has been some anxiety of being misunderstood. The persecution imprint has been prevalent when telling my story but I let it break me open rather than break me. This, paying homage to all the mystics wrongly murdered for their wisdom in their veins. Being in service to healing the strands of womanhood wounding is my purpose in this lifetime. I have helped countless sisters on their journey back to stabilization, restoration, and empowerment. I created an online Divine Feminine Mystery School for women to reclaim what was once taken by accessing ecstasy through the etheric layers of the body and using it to transcend.

I lead in how to access the sweetness of sensuality, remembrance of innocence, the art of surrender, reclamation of pleasure, womb healing, nervous system alignment, cellular regeneration, and gently dissolve trauma, by calling fragmented parts of the self and soul home.

Connect with Bracken on a deeper level:

Facebook: bracken.rainbow

www.WalkingWomenHome.com

Kara Persson
Author of: **Feel it All**

At every step of the healing journey, let tears flow from your eyes in connection to your divinity. From this place, you can manifest the life you've always longed for. Lay it all down, create the space to sink into your feelings - anything goes - let it move you to the most soul-full version of yourself.

We often empty our expression until we become a shell of ourselves, gray, wondering where our aliveness went. When conforming to external expectations, we diminish the richness of our humanity, as if we are inherently wrong in our autonomy.

"It is no measure of health to be well adjusted to a profoundly sick society"
~Jiddu Krishnamurti

Becoming whole, for me, is the journey back to the innocent soul that first began. Feel into the intricacies and depth existing within your body; trust that nature doesn't make mistakes.

My work is living through compassion and harmony to create beauty. I am fulfilled by making things with my hands, finding solutions, and continuing to follow the ever-evolving dreams of my heart. My son inspires me to model integrity, and he will bring those lessons alongside your daughters in a more loving and just world for all.

Connect with Kara on a deeper level:

Social: @karapersson

https://www.karapersson.com

Tam Ann Taylor

Author of: **Roaming Hearts and Wandering Feet**

Collectively we are bringing awareness to Body Dysmorphia Syndrome and mental health. Here, we shine a light on the unhealthy thought patterns that may start to manifest and transform one's life in a negative manner.

My hope in sharing my story is that we choose open and positive communication as women, including that between mothers and daughters.

Sharing our fears and insights with heart, we become stronger and happier alongside one another.

Reconnecting with oneself and healing the relationship with your body is possible through yoga, nature, and learning how to ground with our Earth. Through Yoga and Intuitive Sensual Writing, I share these gifts with women just like you.

I believe that we walk this Earth in togetherness with a belonging in our hearts. While our journeys are all different, we sing the same song.

May we see what needs to be seen, heal the past, learn for the future, emanate growth, and reignite the eternal light inside.

"Synchronising the sacred breath in unison with flowing movement of the body, ultimately transforms the mind and soul"

Connect with Tam on a deeper level:

FB: Intuitive Flow writings & spiritual/sensual poetry by Tammy Taylor

Email: tamanntaylor1980@gmail.com

Live in the sunshine, swim the sea, drink the wild air

Acknowledgements

One of the common themes threaded throughout *Becoming Whole Again* is: *women thrive in a Village*.

From its inception to completion, this vision that is now a beautiful legacy piece would not have been possible without the collective belief, contribution, voice, and creativity of every woman who has added their name, their art, their expertise, their guidance, their witnessing, and their encouragement to this book.

Without the women below this mission that was laid on my heart, this book would not have taken the form it was destined to take. I move in gratitude daily for the nine women who picked up their pens, and dared to ink them and pour their hearts out alongside me.

Jennifer Robertson, Amanda Rumour, Amy Nava, Katie Storm, Ruth Johnstone, Bracken Rae, Lindsay Hart, Tam Ann Taylor, and Kara Cressman, you ladies will forever be in my heart for walking this path hand in hand with me.

The tears you have shed, the words you have written, the doubt you have overcome, the inner sturdiness you have built and, mostly, the voice you have unearthed— has changed me and you. This vision would not have been given the unique imprint it moves with today, without your hands on it and your hearts within it. I feel that even "thank you" doesn't quite do justice to the gratitude I have for each of you.

Ruth Fae, our Editor, a woman who was moved to tears when I first shared with her the vision and mission of this book, we sat and talked for hours, like two old friends who had never been apart, even though we had just met. Ruth, you met every Chapter within this book with such love and openness. We could feel the care you took and the fine-tooth comb that gently elevated our words, the process in and of itself, was one that you brought ease to, every step of the way.

Thank you for being the wind beneath our words, for over-delivering and doing so with oodles of heart.

Sarah Maqboub, your art from the cover to the pieces that adorn every Chapter, brought me to my knees and had tears well in my eyes. As the art for each Author landed in my inbox, I knew who each woman was, right then and there. You brought a depth to this book that I could see in my mind and knew that only the perfect artist would capture so divinely. Thank you.

Victoria Washington, whose voice catalyzed our own and showed us that what we ache for is the thing that will obliterate the doubt. You encouraged us to believe so deeply in ourselves through learning that our body speaks before we even open our mouths. Your invitation to allow more questions than answers to exist opened up fresh waves of creativity and vulnerability. Thank you.

Acknowledgements

Brittany Wylde, who gave us the gift of 'The Golden Thread' and the permission for our writing to be messy and imperfect. The invitation to develop a 'skeleton' was invaluable and something we revisited throughout the entire writing process. Thank you for reminding us of the power that lives in returning to our work with fresh eyes to layer in texture, animation, and emotion. You are a brilliant storyteller. Thank you.

Terrie Silverman, whose simple prompts brought us all to tears, and who showed us that the muse is always there. When we desired to know how, you taught us that the how was already there, within each of us, and that when we create space for the angst and fear to be witnessed, the muse becomes even more clear.

Kori Leigh, after soaking in the words woven within our Manuscript, to receive the vision laid on my heart all done at the 11th hour, you accepted the invitation to pen our Foreword. For you to bring your voice, your energy and have your light to collide with ours as we 'collectively' light up the path of healing and hope for others, we are eternally grateful.

To the men and fathers behind the scenes who believed in their wives and the journey they were embarking on, thank you for your unwavering support and taking the kids so that we could write. Thank you for trusting us to do justice to our stories for our daughters, our sons and the generations to come.

We are the new legacy and we do not take that responsibility lightly.

Nicki, babe. Thank you. Thank you for forever believing in me to unbecome everything known to explore the possibilities that await just beyond the leap. Without your belief in me, this book would likely have remained a far-fetched idea scribbled in my journal, never to see the light of day. And yet, here we are. To you, I am forever grateful. I love you.

To those who were part of our stories, who catalyzed our healing, who perhaps even without you knowing it, encouraged us to become who we are today and walk the lifetime journey of Becoming Whole Again. What an invaluable gift you have given us.

I would like to acknowledge that the magical, brave and wise women in this book and every contributor were brought together by a divine power greater than myself. The seeds were sown for this Village's existence well before we knew.

God, thank you. Thank you for helping us to remove our ego, to write from a higher perspective, to show us the next right step in those moments where we trembled, and doubt entered the room.

And with a big breath and a leap, this book that will birth a movement is now complete.

Here's to weaving sacred ways into modern day, for generations to come.

*As above, so below. As within, so without
….. and so it is*

♡

www.ingramcontent.com/pod-product-compliance
Lightning Source LLC
Chambersburg PA
CBHW042358280426
43661CB00096B/1151